Irene Avaalaaqiaq

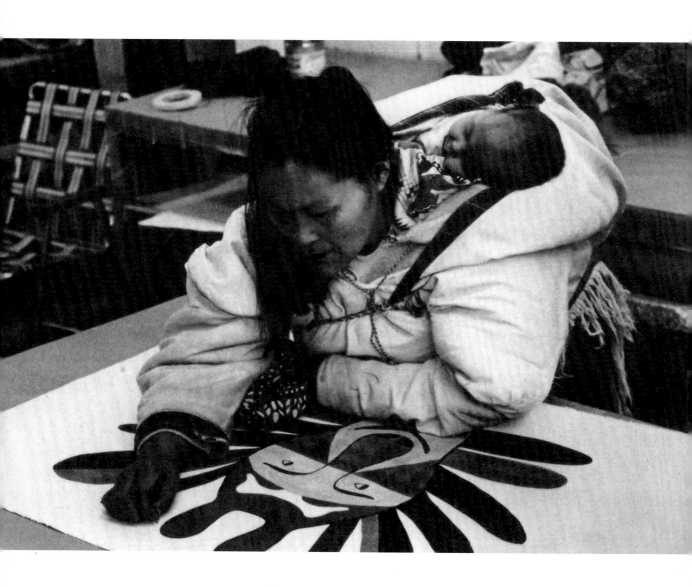

JUDITH NASBY

Irene Avaalaaqiaq
MYTH and REALITY

McGill-Queen's University Press · Montreal & Kingston · London · Ithaca
University of Washington Press · Seattle

© McGill-Queen's University Press 2002
ISBN 0-7735-2440-1

Legal deposit third quarter 2002
Bibliothèque nationale du Québec

Printed in Canada on acid-free paper that is 100% ancient forest free (100% post-consumer recycled), processed chlorine free.

McGill-Queen's University Press acknowledges the support of the Canada Council for the Arts for its publishing program. It also acknowledges the financial support of the Government of Canada through the Book Publishing Industry Development Program (BPIDP).

National Library of Canada Cataloguing in Publication Data

Nasby, Judith. 1945–
Irene Avaalaaqiaq : myth and reality / Judith Nasby.

Includes bibliographical references and index.
ISBN 0-7735-2440-1

1. Avaalaaqiaq, Irene, 1941–. 2. Inuit artists–Canada–Biography.
I. Title. II. Title: Myth and reality.

Published simultaneously in the United States of America by the University of Washington Press, PO Box 50096, Seattle, WA 98145-5096.
www.washington.edu/uwpress/

Library of Congress Cataloging-in-Publication Data
Nasby, Judith. 1945–
 [Myth and reality]
 Irene Avaalaaqiaq : myth and reality / Judith Nasby.
 p.cm.
Includes bibliographical references and index.
ISBN 0-295-98279-9 (alk. paper)
1. Avaalaaqiaq Tiktaalaaq, Irene, 1941– 2. Inuit artists–Canada–Biography.
I. Avaalaaqiaq Tiktaalaaq, Irene, 1941– II. Title.

N6549.A89 N37 2002
709'.2–dc21
[B] 2002067898

This book was designed and typeset by David LeBlanc in Adobe Garamond 10.5/15 in Montreal, Quebec

Contents

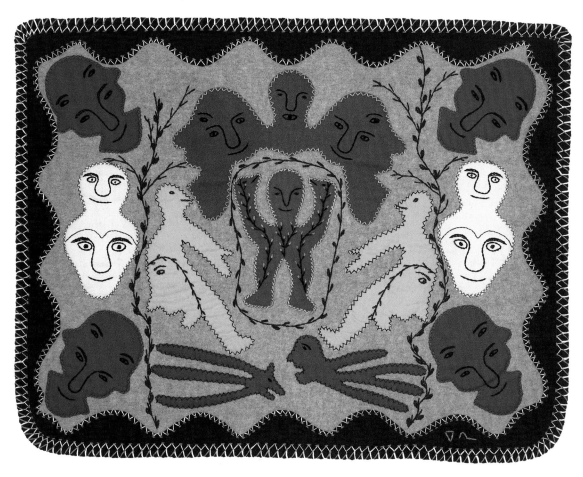

"The red figure in the centre is an Inuk who has triumphed over the animals and the forces that are surrounding him. The lines running through his body represent his veins and the little orange stitches in the veins indicate that the veins are swelling with blood as he raises his arms in celebration. A line of black stitches surrounds the Inuk like a barrier protecting him from harm."

PLATE I
Young Man Out Walking, 1989
wool duffle and felt, cotton embroidery thread

Preface

In October 1999, the prominent Canadian Inuit artist Irene Avaalaaqiaq was presented the degree of Doctor of Laws, *honoris causa*, by the University of Guelph in recognition of her outstanding art work and the contribution she has made to the development of contemporary Inuit art. Avaalaaqiaq delivered her convocation address to 225 arts and agriculture graduates in her native language, Inuktitut, with translation by her friend and art dealer, Sally Qimmiu'naaq Webster.

In recognition of the award presentation, the Macdonald Stewart Art Centre at the University of Guelph commissioned nine art works comprising wall hangings and drawings for the Art Centre's collection. These art works were featured with other recent works by Avaalaaqiaq in a solo exhibition held at the Art Centre at the time of the convocation ceremony, when Avaalaaqiaq was a visiting artist. The text in this publication discusses her life and her remarkable art works, based on interviews with and memoirs by the artist.

My warmest thanks to Irene Avaalaaqiaq for her enthusiasm and commitment to all aspects of this project.

At my request, Irene Avaalaaqiaq taped her memoirs in 1999, 2000, and 2001. The taping and translation was done primarily by Lucy Evo, assistant manager of the Itsarnittakarvik: Inuit Heritage Centre, Baker Lake, Nunavut, with some additional translation by Ruby Mautaritnaak. The project was funded by the Canada Council for the Arts and the memoirs are on deposit with the Macdonald Stewart Art Centre and the Itsarnittakarvik: Inuit Heritage Centre. Editing was done by the author for consideration of clarity and length, while every attempt was made to retain the character of Avaalaaqiaq's speech. Sources for additional quotations by Avaalaaqiaq appearing in this publication are derived from interviews by Judith Nasby in 1999 and 2000, translated by Sally Qimmiu'naaq Webster; and interviews conducted by Marion E. Jackson and William Noah in 1983 and 1985 and by Jackson and Nasby in 1993 in connection with Macdonald Stewart Art Centre's international touring exhibition *Qamanittuaq: Where the River Widens,* which was curated by Jackson, Nasby, and Noah. Further interviews were conducted by Nasby at the 1994 Baker Lake Art Symposium or provided to the Art Centre by Marie Bouchard, Sally Qimmiu'naaq Webster, and David Webster as drawings and wall hangings were acquired for the Art Centre collection.

Acknowledgments

A number of individuals and organizations provided valuable assistance to me. I would particularly like to thank Sally Qimmiu'naaq Webster, owner of Baker Lake Fine Arts Limited, Nunavut; David Webster, the former manager of Ittsarnittakarvik: Inuit Heritage Centre, Baker Lake, Nunavut; Lucy Evo, the former assistant manager of Ittsarnittakarvik: Inuit Heritage Centre; and Marie Bouchard, independent art consultant.

I would like to thank Daniel and Martha Albrecht; John Ayre; Sandra Barz; Heather Beecroft of Canadian Arctic Producers, Mississauga; Blount Canada Limited; Jack Butler and Sheila Butler; Katharine Fernstrom and Anita E. Jones of The Baltimore Museum of Art; Maria von Finckenstein of the Canadian Museum of Civilization; Ken Hammill; Lucy Herman and the late Fred Herman; Avrom Isaacs; Marion Jackson; Judy Kardosh of the Marion Scott Gallery, Vancouver; Chandler Kirwin; Lisa McCollum of the Heard Museum, Phoenix; Doreen Millen; William Noah; David Noakes; Jack and Muriel Poste; Marie Routledge of the National Gallery of Canada; Sam and Esther Sarick; Faye Settler of The Upstairs Gallery, Winnipeg; Tim Struthers; Nancy Sullivan; and Simon Tookoome.

I would also like to recognize the contributions of Len Anthony; Paul von Baich; LaRee Bates and Craig Smith of the Heard Museum, Phoenix; Louis Campeau of the Canadian Museum of Civilization; Christian Coloumbe; Steven Fick, cartographer for the Canadian Geographic Magazine; Peter Green; Jocelyn Limoges of Public Works and Government Services Canada; Debra Moore of the Hudson's Bay Company Archives, Winnipeg; Zach McLeod; Poul Mørk of the National Museum of Denmark, Copenhagen; Dean Palmer; Barry Pottle of the Inuit Art Centre, Indian and Northern Affairs Canada; John Reeves; Martin Schwalbe; Vernon C. Thomas of the University of Guelph, Department of Zoology; Henry Vuori; and John W. Wyne.

For their ongoing commitment, I wish to thank the staff of the Macdonald Stewart Art Centre, including Sorouja Williamson, Verne Harrison, Shelley Langton, Deborah Davis, Dawn Owen, Vanessa Fewster, and Shannon MacDonald and also the Art Centre Volunteers.

Thank you to Marie Bouchard, Anne McPherson, and Sarah Nasby for reading drafts of the manuscript, to David LeBlanc for his book design, and to my external reviewers, my editor, Philip Cercone, and my coordinating editor, Joan McGilvray, for their insightful advice.

Thank you to the Canada Council for the Arts for supporting scholarship on Inuit art by contributing to this publication, the first monograph on Irene Avaalaaqiaq.

JUDITH NASBY

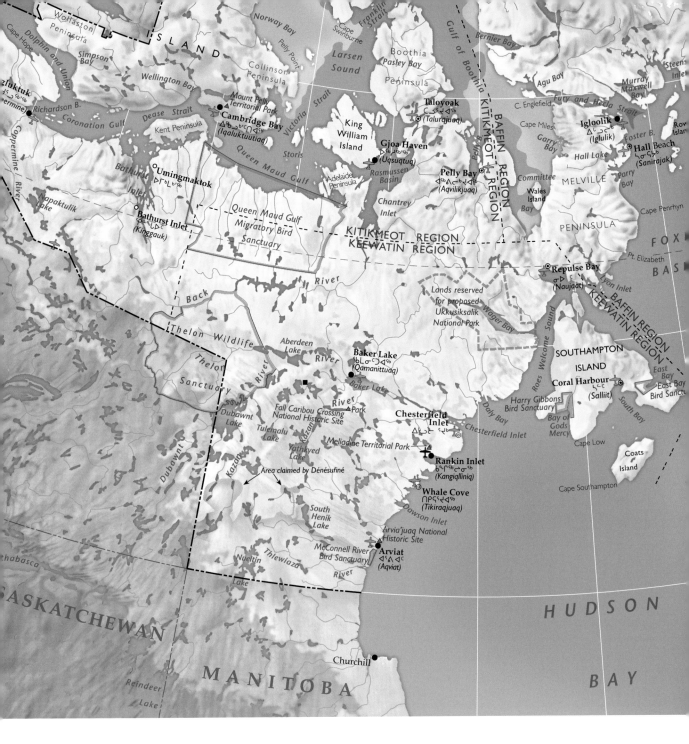

Map showing Baker Lake (Qamanittuaq)
● on the northwest shore of Baker Lake

Avaalaaqiaq's birthplace
■ 100 kilometres west of Baker Lake

Individuals Mentioned in the Text

This list covers the period from Avaalaaqiaq's childhood until she settled in Baker Lake.

(M) and (F) indicate gender when not otherwise clear.

Aasivak (M)	Leader of a neighbouring camp when Avaalaaqiaq was a child
Amaaq (F)	A young child from Aasivak's camp
Arngaqyuinnaq, Mrs	Baker Lake resident
Arngnasungaaq	Avaalaaqiaq's grandmother
Arngnasungaaq, Angaryuk	Avaalaaqiaq's uncle
Attungala, Norman	Norman and his wife, Winnie, lived in a neighbouring camp when Avaalaaqiaq was a child
Aulinguaq (M)	A member of Haqpitnaaq's camp, where Avaalaaqiaq was living when her grandmother died

Gualittuaq, Marjorie Avaalaaqiaq's mother

Hanguhaaq Wife of Iksiktaaryunaaq

Haqpitnaaq (M) Leader of a neighbouring camp when Avaalaaqiaq was a child

Hattie Daughter of Aasivik

Havaa (F) A member of Siksigaq's camp

Iksiktaaryunaaq Iksiktaaryunaaq and his wife Hanguhaaq adopted Avaalaaqiaq after her grandmother died

Ikuutaq A member of Siksigaq's camp

Itiplui, Peter Avaalaaqiaq's father

Ittulukatnaaq Avaalaaqiaq's uncle

Nanautuaq (Martha Nukik) Avaalaaqiaq's cousin and wife of Haatnaaq (John Nukik)

Nguanguaq (M) A member of Siksigaq's camp

Niviq (F) Baker Lake resident

Pukiqtuk Avaalaaqiaq's grandfather

Qaqsauq (F) Baker Lake resident

Siksigaq, Joseph Adopted Avaalaaqiaq after his brother Iksiktaaryunaaq died

Simailak A child living in Baker Lake

Taviniq (F) A member of Iksiktaaryunaaq's camp.

Tiktaalaaq, David Avaalaaqiaq's husband

Ukkusiksalingmiut (M) Baker Lake resident

Winnie (F) Baker Lake resident

Irene Avaalaaqiaq

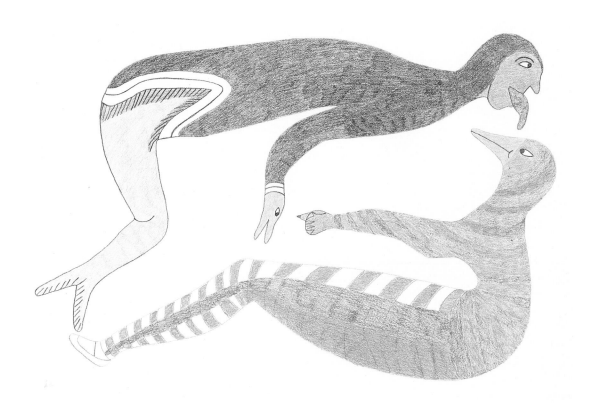

PLATE 2
Men Who Want to Be Animals, 1999
coloured pencil on paper

Whenever I see my wall hangings they remind me of my life. Also I always remember my grandmother and the stories and legends she told me. When I grew up there were no other people except my grandparents. I had never seen white people. When I do sewing and make a wall hanging I do what I remember. I can see it clear as a picture. When I am looking at it, it looks like it is actually happening in those days, as it was in my life.

IRENE AVAALAAQIAQ, 1999

Where Myth and Reality Intersect

Irene Avaalaaqiaq, one of Canada's most prominent Inuit artists, has a distinguished thirty-year career as a distinctive creator of wall hangings, drawings, and prints. Avaalaaqiaq's art is grounded within the realm of storytelling and her life's experience. Myth and reality intersect as she translates multi-layered stories, transformation scenes, and personal memories into bold graphic imagery. She approaches drawings, prints, and wall hangings in a similar manner, by manipulating bold shapes in bright contrasting colours against a solid background to represent her world in a symbolic manner. This approach has been consistent in her work since the early 1970s and provides her with a powerful tool to abstract grand concepts of time, space, narration, and movement.

Avaalaaqiaq lives in the Nunavut community of Baker Lake, or Qamanittuaq, as it is known in Inuktitut, which is located approximately 250 kilometres south of the Arctic Circle and has a population of 1,500. A number of the settlement's sixty artists have achieved international recognition through major exhibitions and inclusion in public collections. Baker Lake is Canada's only major inland Arctic settlement and is known for its sculpture, wall hangings, stone cuts, serigraphs,

stencil prints, and coloured pencil drawings. In their work the artists draw upon their rich heritage of shamanistic and spirit imagery for inspiration. Each artist expresses a singular vision, rooted in tradition and history, while living in the midst of a world affected by present and future technologies.

The wall hanging is a particular specialization of a group of Baker Lake women artists who excel at this medium. Avaalaaqiaq, one of the younger members of this group, brings her own vision to the task of creating striking imagery within the confines of a medium consisting only of wool fabric and embroidery thread.

Her unique vision is expressed in large, highly coloured, and abstracted works that are enlivened with embroidered lines. Avaalaaqiaq's world view is derived from an oral tradition and is expressed in a symbolic manner that compresses time, location, narrative, and the depiction of movement into timeless images conveying layers of meaning. Her life, first on the land and later in the lively community of Baker Lake, is a source of her imagery, as are the stories she heard from her grandmother by the light of the *qulliq* (lamp) in snow houses and caribou skin tents. An amazingly prolific artist, Avaalaaqiaq brings to her art a strong commitment to preserve her heritage and to make it accessible to her community and to a wider international audience.

Avaalaaqiaq believes she was born in 1941. However, she once met someone who told her that he remembered her as a child and that she was actually born in 1936. She said dates were not recorded then for births on the land, and the only date she remembers for certain is the date of her marriage in 1956 to David Tiktaalaaq. She identifies her birthplace as the north shore of Tebesjuak Lake, approximately one hundred kilometres west of Baker Lake. The people living south of Baker Lake in the vicinity of the lower Kazan River are known as the Harvaqtormiut, or the people of the whirlpools. They are part of a larger group known as the Caribou Inuit of the Barren Grounds lying west of Hudson Bay.

The Harvaqtormiut were visited at the end of the nineteenth century by the explorer David Hanbury and by the survey geologist Joseph B. Tyrrell. Tyrrell was hired by the federal government to map rivers in the Kivalliq (Keewatin) region, and owing to the fact that he did not speak Inuktitut, he left no appreciable observations. The significant ethnological study of the Harvaqtormiut and the Padlermiut, who inhabited the upper Kazan River area, was conducted by the

Danish ethnologist Knud Rasmussen and his associate Kaj Birket-Smith. Their observations of trips undertaken in 1921–24 were published in the *Report of the Fifth Thule Expedition*. Rasmussen and Birket-Smith recorded a way of life that was similar to Avaalaaqiaq's early years.

In relating significant events from her life, Avaalaaqiaq mentions names of a number of Inuit. Many of these names appear only once because these individuals were members of various nomadic camps that she encountered before moving to Baker Lake with her husband. An index of names is provided on page viii for the reader's reference.

Avaalaaqiaq explains the circumstances of her birth:

I was born at Uluttuaq past Qigaugattuaq. My mother, Gualittuaq, died in the spring shortly after I was born and my grandmother saved me. She poured a little bit of milk from a caribou breast into my mouth when I was a newborn because she couldn't breastfeed me. Later my grandmother fed me caribou broth by taking it from her mouth and putting it to mine. I remember living out there and I was the only child. I grew up with my grandmother Arngnasungaaq and my grandfather Pukiqtuk. Because my father, Itiplui, was a man he couldn't look after a child, so my grandmother adopted me. There was no one else around. Only the three of us, my grandmother, my grandfather, and myself.

Her father and other relatives visited only occasionally, and when she was still young her grandfather died. Often she would be left alone in the tent while her grandmother hunted, as food was continuously scarce. Although she and her grandmother did not suffer the extended periods of starvation that other groups endured or succumbed to during this period, their life was hard with few resources.

She recalls that at times they endured periods up to three days without food, and had very limited contact with other nomadic families.

I remember [neighbour] Norman Attungala and his wife, Winnie, came to visit us around 1950 or 1951. They didn't have any children at the time. It was a

big thing for me, seeing another human being. Because we lived in isolation when the couple came it looked as if we finally had other human beings with us. Haqpitnaaq and his family were close neighbours even though they weren't that close. I didn't know anything about such things as sweets. Once in a very long while, the only sweet that we would get was powdered milk and sugar. The only time we would get these was when Haqpitnaaq went to the settlement to get food in the wintertime. In the summer my uncle Ittulukatnaaq would come to visit my grandmother by walking from a far distance.

My grandfather couldn't walk for a long time before he died. When he passed away my grandmother and I were alone. I used to be alone when my grandmother went out hunting using a .22 rifle. One time my grandmother was out hunting and saw smoke. She thought that the Haqpitnaaqs were making smoke signals for her to come. She walked to the Haqpitnaaq camp and found out that they didn't send a signal. She followed the smoke and saw two men she didn't recognize. She said she couldn't understand them and thought they were Dene. The two men gave her a full box of .22 bullets and a big bag of loose Red Rose Tea. There were quite a few Dene around but we didn't know them.

Winter camp, Kivalliq (Keewatin) region, c. 1930s

My grandmother and I lived in *itsaq* (caribou skin tents) for a long time. The only time I saw canvas tents was when I moved closer to Baker Lake.

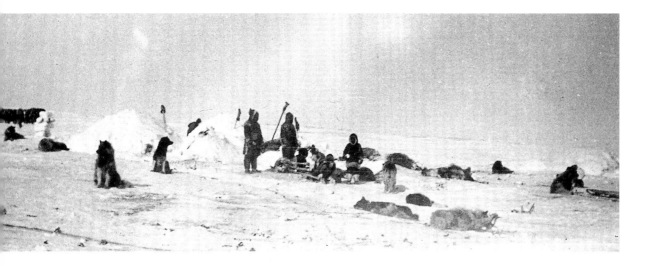

Itsaq are useful in the fall because they are warm, and in the spring they are cool compared to canvas tents. They can be made differently with one pole or lots of poles. The only problem is that they can be dark inside. They were the only shelter we had so it didn't bother us. We used fat from the outer part of the stomach of the caribou for lighting. The *qulliq* kept the tent warm and we also cooked with it. Once I cooked on rocks when we were stranded. I like meat that is cooked on rocks. To cook on rocks we arranged a flat rock on top of the fire and carefully placed *uqyuk* (wet weeds) on top of the meat. The meat cooks like it is cooking in a pot. We made sure the meat was covered completely with moistened *uqyuk*. The meat is delicious cooked like that, even without gravy, because the meat makes its own gravy.

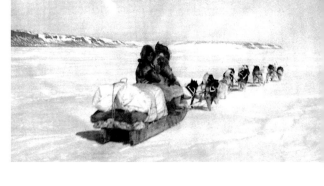

Dog team travelling in the Kivalliq (Keewatin) region, c. 1930s

Once I was at Qigaugattuaq where there is a river. It was in the fall and Haqpitnaaq was with us. The water had just recently frozen over. Our clothing was made out of caribou skin, which was the only clothing we wore. As we were playing on the ice it started moving. I was really enjoying it and was a little way from the others. Suddenly I fell into the water and the legs of my caribou skin clothing stuck to the ice. I was saved by being pulled out quickly. I was told not to play there anymore.

A long time ago we used rocks as toys and would carry rocks on our back. We were told not to have rocks as dolls because we might have children that are heavy. Now they want mothers to have heavy babies. There were lots of rules to follow.

Avaalaaqiaq and her grandmother lived near Mallery Lake and would make periodic visits to her mother's grave. She recalls the first time she saw her mother's grave.

A long time ago people would put useful items on the grave, such as a teapot. At my mother's grave there was a record player made out of metal and lots of

records. I always remember the record player that you had to wind manually and the records that were piled up. When my grandmother went to the grave she would carry me on her back and she would cry. I used to wonder why she would cry when my mother wouldn't wake up. I would tell my grandmother that I wanted to play with the record player. She told me that it was my mother's and no one is to touch it and it has to be left on her grave.

I remember vividly in 1950 or 1951 when the RCMP came to our camp by dog team, I would look intensely at them. The RCMP traveled far distances to our camp. I was so scared since it was the first time I saw *qablunaat* (Caucasians). We were timid because we lived in isolation. The RCMP had big white dogs. I asked my grandmother, "Are those dogs little foxes?" We didn't even have dogs then. I was amazed at the white dogs and thought that they were foxes.

A special bond developed between Avaalaaqiaq and her grandmother as they worked together for survival, and as her grandmother ensured that Avaalaaqiaq learned about a culture that was rapidly eroding.

In the evenings my grandmother would relate stories. Inuit did not write their history down like people in the South but we passed on our traditions, culture, and values through an oral tradition. Through the oral tradition our ancestors were our teachers.

I try to keep our culture alive through my art. Art is a way to preserve our culture. Most of the stories and legends had a moral to them and we would use the values taught to us in our everyday life.

After my grandfather had already passed away, my grandmother and I lived with the family of Haqpitnaaq. My grandmother was sick for a long time. Aulinguaq [a member of the camp] and others returned from picking up supplies of food. Aulinguaq brought my grandmother half a bag of flour and a big cup of tea … I was always with my grandmother.

Aulinguaq woke me up and said, "Hey, Avaalaaqiaq, get dressed." I wondered why he wanted me to get dressed. I thought my grandmother was awake for a long time. She was lying with her arms on the pillow and looking at the doorway with her eyes open. He said to me, "Your grandmother is not breath-

ing anymore. She died. Get dressed and go outside." Of course I started cry-
ing. I didn't have a place to stay anymore. I wasn't even thinking if her body
was cold. I started getting dressed. She died. [Irene was in a deep emotional
state when she talked about her grandmother's death.] Haqpitnaaq said that he
was going to pack up and go. He said that we would bury her. We went to go
bury her where there are graves at Ulutuaq point. In the grave there were my
grandfather Pukiqtuk and his grandmother Tikigiaq and others.

Haqpitnaaq said that he couldn't bring up girls so Iksiktaaryunaaq's family
adopted me and I began living with them. That time we used to listen to our
elders even though we were scared. I was living outside and I was scared. It
was windy since it was Spring. I was really scared since this is the first time
I've seen so many people. We started travelling again. Iksiktaaryunaaq didn't
have any children, but he had a wife named Hanguhaaq. I thought that we
would travel forever. It was my first time to go away from my camp too.

We visited with Aasivak's family [in a neighbouring camp], who had anoth-
er young person, Amaaq, with them and I was so happy to finally be with
another young person. We had tea together and ate since we were going to
part. Aulinguaq gave Amaaq and me what he was chewing in his mouth so
that we would live longer. Both of us felt sick to our stomach. We chewed
for a long time but it was hard to swallow, so we spit
it out. To us it was gross so we gave it to the dog. We
probably already had swallowed the germs.

I've never worked at picking up twigs. My grand-
mother did all the work by herself. We lived where
there were no twigs but there was moss around.
When I first started making tea, I was so clumsy.

At a young age Avaalaaqiaq had to face the death of her
grandmother, which left her feeling "totally alone and
scared." She became an orphan, without any relatives to
adopt her. Arrangements were made for her to be adopt-
ed by Iksiktaaryunaaq and his wife, Hanguhaaq, and
later she lived with the family of Joseph Siksigaq after

"Harvaqtormiut from a
camp at lower Kazan River
where women and children
had never seen white men."
Kaj Birket-Smith, 1922

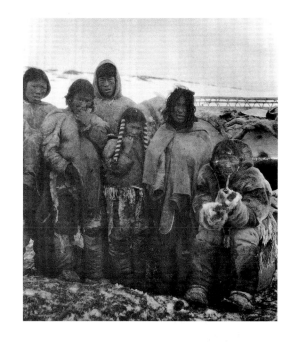

Iksiktaaryunaaq died. With Iksiktaaryunaaq and her adoptive family she continued to live a nomadic lifestyle but with more traveling and with the additional challenges of integrating into a new family group. Photographs of the camps documented in the 1920s and 1930s are similar to but not exactly like the camps that Avaalaaqiaq lived in, particularly since she suffered such poverty that at times they had no dogs or sleds. The status of her lifestyle varied, depending on the availability of materials and their success with trading items. Life on the land meant a continual cycle of hunting and storing food. For these inland Inuit, far from the sea, the predominant food source was caribou, supplemented by fish from the rivers and birds. When caribou herds were scarce, particularly during her childhood and early adulthood, the possibility of securing a single caribou could mean the difference between life and death for a small family unit.

Her massive portrait *Woman Fleeing Evil Spirits,* 1993 (plate 3) portrays a woman alone on the tundra assuming the head of a bird as she enters a transformation. In this wall hanging the woman has achieved a mythic union with one of the sources of her survival. Traditionally the intervention of the shaman was viewed as a means to ensure plentitude and a successful hunt and to protect against evil spirits. The boldness of the image is reinforced by Avaalaaqiaq's use of strong contrasting colours of red, black, and white. This portrait is also a link to her own childhood experiences of loneliness and fear. Having lost her mother and caring grandparents at a young age, her early life was one of uncertainty as she was forced to adjust to new circumstances.

The ethnologist Knud Rassmusen visited the Harvaqtormiut settlements in the spring of 1922. On 9 May he set out from Baker Lake, which is located on the shore of a large inland lake where the Kazan River terminates. The settlement of Baker Lake was already the major trading centre for a wide group of Inuit because of the presence of the Hudson's Bay Company post. Traveling by dog team, Rassmusen followed the course of the Kazan River from the dramatic falls at the river mouth into the interior.

At this time of year the sun would melt the surface of the snow and the cold temperature of the nighttime would freeze it into a slick icy surface, making travel by dogsled difficult at times. Rasmussen commented,

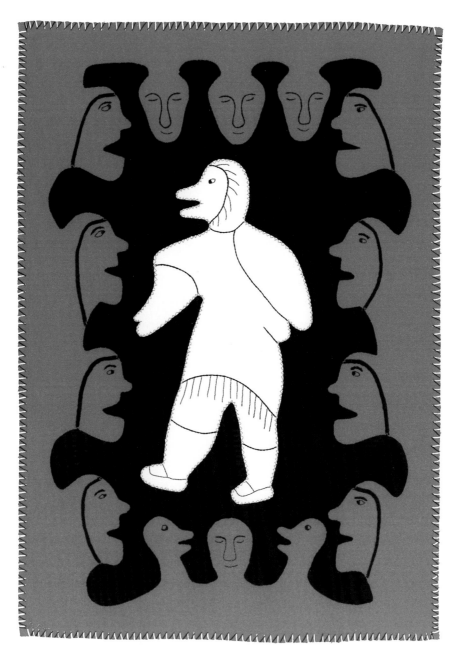

PLATE 3
Woman Fleeing Evil Spirits, 1993
wool duffle and felt, cotton embroidery thread

The more we learned about these people, (we) came to the conclusion that
… we were face to face with an Eskimo culture that could only be regarded
as a survival of a very ancient Eskimo culture, perhaps, indeed, a Proto-
Eskimo culture from the time when the transformation to the coast culture
had not yet taken place …[1]

It was not without excitement that we made our way into the complexity
of the Barren Grounds. On the way we heard many harrowing tales of the
privation that had prevailed there that winter, and a policeman from Chester-
field, who was out tracking a murderer, was said to have had extraordinary
difficulties to contend with, as, wherever he came, the Eskimos were starving
and in need. Here, where all the hunters have to base the whole of their
livelihood upon caribou hunting, disaster very quickly arrives when this fails.
The most dangerous time is always the two months that precede the great
caribou migration at the end of May, when the animals come from the
woodlands to work their way down towards the coast. If the Eskimos have
no cached supplies to fall back upon, March and April are always fateful.[2]

(With the hindsight of eighty years it is hard for us to understand why, when gov-
ernment representatives were obviously aware of the deprivation and needless
deaths of these nomadic Inuit, the federal government did not take action to pro-
vide assistance. It was not until the 1950s, when another serious cyclical time of
food shortage occurred, that action was taken to assist nomadic families to move
into settlements such as Baker Lake where housing and medical and education
services were provided.)

Rasmussen discovered that one group, the Tahiuharmiut, had died out through
starvation three years before. While visiting a Harvaqtormiut village he witnessed
people who had just managed to survive the winter by catching trout after their
autumn stores of caribou meat were depleted.

He was also present to see the remarkable event of the start of the caribou herd
migration from the interior towards the Hudson Bay coast. The village immedi-
ately decamped to move to more favourable hunting grounds. The return of the
caribou also meant the approach of summer and a time of abundance.

At another village he witnessed the arrival of a family who traveled by dog team from another camp. They immediately shared their caribou with those who were starving.

On the floor lay two shoulders of venison (caribou), raw but inviting – gifts from the (neighbouring) village; and now, when hunger no longer gnawed, the desire for song had immediately welled up in them. But I could hardly believe my eyes when I saw them all, old and young, eagerly absorbed in gambling with small, fine playing cards that had been imported from Winnipeg. Laughter and merry cries alternated with the claps of thunder.[3]

Ethnologist Kaj Birket-Smith commented,

I will never forget the widespread joy at a small camp at Kazan River, when the inhabitants had obtained so many caribou "that we do not keep count of

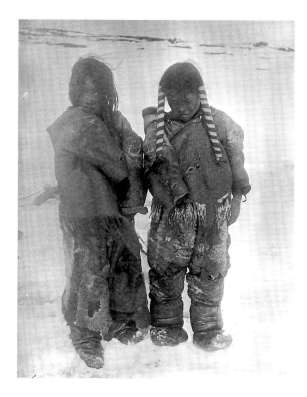

"Two little Harvaqtormiut girls, dressed in rags because their taboo debars them from getting new clothes in spring and summer. One of them is wearing her hair in *tu'dlit*: wooden sticks round which hair is wound and bound with strips of caribou skin, *tu'dlit* are worn partly for ornament, partly to keep the hair in order." Knud Rasmussen, 1922

them" – nor the Homeric feast, consisting exclusively of caribou heads; in which we participated.[4]

Historian Calvin Luther Martin points out that there is a distinct difference between the feast and fasting regime of hunting cultures and incidences of real starvation. Seasonal changes and the need to constantly move in search of food led to episodes of binge eating, but hunting peoples were efficient storers of fat, which allowed them to fast for periods of time when game was not available. Hunting cultures believed that the landscape would always sustain them through nature's ability to endlessly cycle and recycle.[5] However, as Rasmussen and Birket-Smith observed, the Caribou Inuit were particularly vulnerable to starvation as their only major food source was the caribou, and when the herds were in cyclical decline the Inuit faced a serious situation.

Each family member performed a ritual role in the securing, preparation, and storage of food. Traditionally young girls would be trained in the preparation of skins, the making of waterproof caribou skin clothing, which would be sewn with sinew, the making of boots and skin tents, responsibilities of caring for the *qulliq,* cooking, gathering berries and moss, and other household needs. Boys would be taught hunting, dogsled, and kayak skills, the making of *iglu,* and other survival techniques. It was crucial that young children be taught and given responsibility, as the continuing survival of the family was based on their successful mastery of these essential skills. Because Avaalaaqiaq was an orphan she was expected to learn all manner of hunting and camp skills. She recalls fearful and anxious moments in learning new skills, as well as her accomplishments.

Iksiktaaryunaaq would say that he didn't have a son, so he tried to teach me how to trap foxes and hunt caribou. I was so scared that I would cry. (I am now just going to tell what happened and I am not going to feel resentful.) Taviniq [a member of Iksiktaaryunaaq's camp] was expecting and we were in need of food since we were alone. The men were out of our camp and women were alone in the camp. Taviniq and I were trying to set nets into the water. The nets didn't go in very far since we were small. It was hard to catch fish in the summertime.

Taviniq and I were told to go get food from Siksigaq [Iksiktaaryunaaq's brother] and Aasivak. Right away we went since it was the only thing to do. We were living at Timanaqtuaqyuk and they were at Anitguq. There was plenty of food there. There was dried meat and so on. They gave us a very small piece of hip bone with very little meat on it. There was lots of dried meat around in their camp.

The next day we were told to go get more meat. I felt for the people who were hungry and yet was feeling hurt about the people that had meat but wouldn't give any. Taviniq and I went to go get food again and spotted a lone caribou. It was the only one we saw. Taviniq caught the caribou as it was going in the lake. I was trying to hold onto the dog while Taviniq was trying to kill the caribou. The caribou fell into the water and she and I went into the water and pulled the caribou out. We were so happy. We tried to take every part of the caribou home but it was difficult because Taviniq was expecting.

We were in need of food again shortly after. The men had gone to another camp for food but were refused. Taviniq and I were left alone in a skin tent. There was an old boat with lots of holes in the bottom. Taviniq and I tried rowing the boat but it kept sinking. It was impossible. Taviniq and I were alone and saw a human being on top of a hill. It happened to be my (uncle) Angaryuk Arngnasungaaq. When Arngnasungaaq was young he used to be

When the caribou were first made. *Once upon a time there were no caribou on the earth. But then there was a man who wished for caribou, and he cut a great hole deep in the ground, and up through this hole came caribou, many caribou. The caribou came pouring out, till the earth was almost covered with them. And when the man thought there were caribou enough for mankind, he closed up the hole again. Thus the caribou came up on earth.* Told by Kibkârjuk. Knud Rasmussen, 1922

a fast walker. He walked a lot and walked for long distances. He brought some *qablunaat* food for us and made us two bannocks. It seemed like so much food.

I used to wonder why Iksiktaaryunaaq was living where there were no caribou around. Since I was the only young person around, I was told to go get more food. I walked over to the same people again to get food. This time I received a bigger piece of meat, the hind quarter. My cousin Nanautuaq [Martha Nukik] came to meet me since I was alone.

We walked to a place called Ingnirit where there are two *inuksuit* (plural of *inuksuk*), which are markers made of piled stones used to give direction or to signify a special place. Nanautuaq and I started praying that no caribou would come because when people are in need of food they can be very frightening. Nanautuaq and I prayed in a bad form also because we were going to be parted. All summer there was no caribou and we were in great need of food now. We had prayed in a wrong way. We were probably thinking about the people that were being stingy with food. I'm sorry for praying like that now.

In the springtime we went back to Anitguq at the river crossing. Scottie's group came to pick up my cousin Nanautuaq. She was to wed Haatnaaq (John Nukik). I cried my heart out while getting water and wondered why do they have to pick her up? She was the only young one around besides me.

We were spearing caribou at the river crossing. There were plenty of caribou. Iksiktaaryunaaq instructed me how to spear caribou. At that time I didn't know that whoever touches a caribou first, it is to be his or hers. I was told that I caught a caribou even though I only speared it once. Then we started skinning the caribou.

I followed what Iksiktaaryunaaq instructed me to do when trapping foxes. I took my foxes home and put them inside the *iglu*. I was trying to do what Iksiktaaryunaaq would do to the foxes. He would strangle them and knock the foxes out. The foxes that I caught would come to life again.

I would cry when I tried to strangle a fox. Once the foxes got hold of a stick they wouldn't let go and they would also try to bite my pants. I used to wear caribou skin clothing and that's why I was safe when the foxes bit my

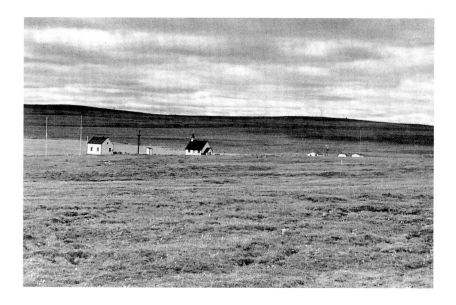

Baker Lake, showing
St Aiden's Anglican
Mission and the tents
of visiting Inuit, c. 1946

pants. I would hit them but they wouldn't die and once they bit my pants,
they hung on so strongly.

I was still living with Hanguhaaq [Iksiktaaryunaaq's wife] when we went to
get food from Baker Lake. This was the first time I went there. There were so
many lights it was scary. We went to Sandy Lunan's place right away and had
molasses. It seemed so sweet. We also took frozen foxes to the church. One
time Hanguhaaq and I took a frozen fox to church as an offering. It was
skinned though. They would just accept that.

Hanguhaaq was Roman Catholic and Iksiktaaryunaaq was Anglican. We
went to church and were separated. The Roman Catholics and Anglicans
were really strict with their congregations. I would go to the Anglican church
and Hanguhaaq to the Roman Catholic church. Right after church I ran to
Hanguhaaq. The snow broke under my feet and I fell down into an *iglu*. I
think it was Ukkusiksalingmiut's *iglu*. It was dark too and I was so scared. It
was a *qarngmak* (abandoned *iglu*) that I fell into. There was no one there
because everyone was at the church.

The people that lived in Baker Lake were always in need of caribou meat
because there was no caribou near the community. There probably was

caribou around but they didn't have any hunting equipment to go out hunt-ing. Once they started working they were not allowed to go out hunting.

Before we became Christians my grandparents would get everything done by the end of the week, like we do now, and rest on Sunday. My grandmoth-er used to say, somewhere up there is a big man, over the clouds. We knew there was something up there. This was before we heard about Jesus and before we got the Bible. My grandmother discouraged me from getting involved in shamanism. We used to respect our elders or someone special and I still believe in that. There is something greater than we are.

In 1922 Rasmussen undertook a study of the religious ideas of the Caribou Inuit. He interviewed a shaman named Igjugârjuk, who relayed information about Hila and Pinga:

Hila was a merciless and terrible power, in winter it was everlasting blizzard and gale, in summer: rain.[6] … The mistress of the animals of the hunt (is) Pinga (who) lives somewhere up in the air or in the sky … she is the guardian of all life, both man and animal, but she does not offer man eternal

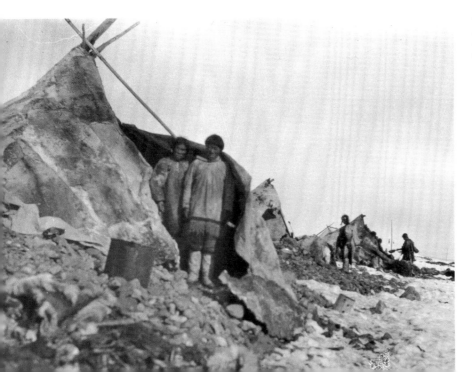

"The shaman Igjugârjuk and his wife outside their skin tents." Knud Rasmussen, 1922

hunting grounds like the godhead of the coast dwellers; she collects all life on the land itself, and makes it eternal solely in this manner, that everything living reappears there.

When an animal or a person dies, the soul leaves the body and flies to Pinga who then lets the life or the soul rise again in another being, either man or animal. As a rule there is no fear of death, and I remember that Igjugârjuk would sometimes say half jokingly, that he had undoubtedly been so imperfect as a human being that his soul, when it went to Pinga after his death, would only be allowed to rise again as a little, burrowing lemming … the animals have definite laws for their wanderings and no shaman can interfere in these. And their shaman philosophy is such as is expressed through Igjugârjuk's statement of how true wisdom can only be attained through sufferings in solitude of almost sublime simplicity.[7]

The role of the shaman was primarily as a healer and protector from evil created by others. Only a few individuals were chosen to begin the long and arduous task of training to become a shaman. Rasmussen also discovered that there were a number of taboos that had to be followed, such as that no animal product from the coast could be mixed with an inland animal; that only a special seamstress would be allowed to sew with bearded seal skin; that when a caribou is killed, the blood and entrails must be covered up.

In the late nineteenth and early twentieth centuries missionaries were active in the Canadian Arctic, through periodic visits made by clergy to outlying camps and later in the establishment of churches in communities like Baker Lake. Many Inuit became Christians and began incorporating Christian worship into their lives. This included visits to the settlements for Christmas and Easter celebrations and for marriage ceremonies. At the same time, many traditional practices continued, such as the responsibilities of a family to select marriage partners for their children around the time of puberty. Avaalaaqiaq is of this generation: she was married in her early teens to David Tiktaalaaq, who was thirty years old.

Soon after Iksiktaaryunaaq started getting sick. He was sent to a hospital for tuberculosis in Chesterfield Inlet. The big minister (Canon James) came to

inform us about his death. His grave is in Chesterfield Inlet, which is not far, but we couldn't get the body back to his land.

After Iksiktaaryunaaq died I moved to his older brother Joseph Siksigaq's family. Siksigaq was very kind but I was scared of his wife who was too strict. I used to always want to eat, but was afraid to eat too much. I wasn't even allowed to eat any crumbs. She would always tell me my clothes were dirty even when they were frozen. I would be the only one to gather moss for the fire and be the only cook. There were a lot of hardships I went through. I am going to tell the true story of my life. I used to get beaten up, even my hair would be frozen, soaked with blood from being hit by her throwing stones at me, if it wasn't the stones it would be a snow beater. Although there was a lot of food, dried meat and frozen meat, I wasn't allowed to even pick some crumbs. I was always thankful to Nguanguaq [a member of Siksigaq's camp]. She would give me some food, just a mouthful, to have while I went to get some water. I wasn't allowed to have berries in the summertime. They would tell me to pick berries, but I wasn't allowed to eat and pick at the same time. Every time, they would tell me to open my mouth to see if I ate any berries. After my grandparents died I never saw anything happy until I got married.

When I was living with Siksigaq's family, Siksigaq told me, "You should get Tiktaalaaq as a husband now." I never really saw him so I was scared. Tiktaalaaq became my husband in 1956 on August 9 when we went to Baker Lake to be wed.

At Baker Lake there was a big dance over at Sandy Lunan's shed. There were also *qablunaat* there. In those days people used to sell piles of caribou skins that were tied together. I was hiding behind those piles of caribou skin while they were dancing. Young Simailak [a child living in Baker Lake] was really becoming attached to me and wanted to be carried on my back. I was so thankful to Simailak for doing that. Little Simailak didn't want me to go out. When I went to the house after the dance Ikuutaq's and Siksigaq's families were sleeping. My husband, Tiktaalaaq, was sleeping too. I made a bed on the floor and was trying not to make any noise. I was so happy that they were sleeping. Ikuutaq [a member of Siksigaq's camp] woke up and started telling me off. Everyone was awake now. Ikuutaq said, "What are you doing making

a bed? You are married now." Ikuutaq was scolding me. I was so scared of them and my husband Tiktaalaaq. The next day Tiktaalaaq went to check the nets. I started thinking in my mind, I hope he drowns. I was thinking in a very bad form. Whenever someone came to visit us it used to be so embarrassing for me.

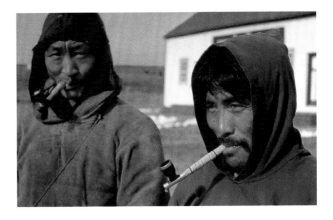

After we were married we lived with Ikuutaq's family out on the land near Baker Lake. We were in need of food so we walked a long distance to Qiqitaryualik where there was lots of fish. We spent some time there. First Siksigaq got sick, then Tiktaalaaq got sick for a long time. A baby had measles and I used to carry the baby on my back. The baby felt so coarse because of the measles. While Tiktaalaaq went out to go get his cached meat Siksigaq passed away. Then Siksigaq's adopted baby died. The priest came from Baker Lake to visit us at our camp. He gave me sugar that looked like pills but when you put them in tea they had a strong taste. In the spring Tiktaalaaq went to Baker Lake. Before he left he built an *iglu* for me and Ikuutaq. The daylight was becoming shady because it was becoming springtime. Tiktaalaaq was away for a long time in Baker Lake.

Joseph Siksigaq (right), Avaalaaqiaq's adoptive father, and V. Makpaaq, a Baker Lake resident, smoking pipes they made. c. 1950

Ikuutaq always wanted me to pick gray hair and lice from her head. But she didn't have any. Every night she wanted me to look for head lice. I was scared of her. After awhile I started nodding my head from being sleepy. She punched me on my forehead and said, "How sleepy you are!" I was startled and was wide awake then. It was hopeless looking for something that wasn't there. There was a rifle on top of the porch. I started thinking that I would take either the rifle or the dog and run away during the late night. She started fighting me again. I quickly put my mitts on and opened the doorway of the *iglu*. She quickly went onto the floor naked and grabbed me by my hood. While I was trying to go out she tore part of my hood. She shouted at me, "Because you are sleepy, sleep then!" I had no choice but to listen to her. I went to bed. All my life the only possession I had was a Bible. I took hold of

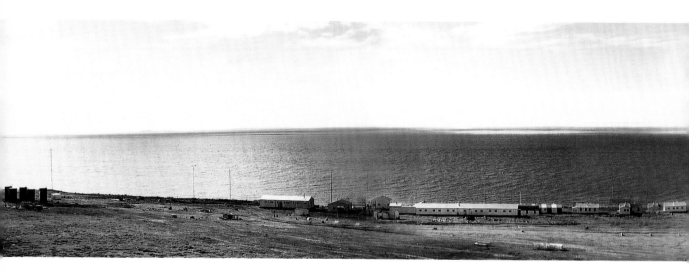

my Bible and hugged it and went under the blanket. I prayed, "Please, Lord, let me just fall asleep." I heard her sharpening her *ulu*. I started thinking that she would stab me. I heard her moaning in pain and I thought that perhaps she had stabbed herself. I pretended to sleep but heard her moaning and calling my name. She said, "Avaalaaqiaq, let me drink." I got up and in my mind I visualized her stabbed. She said that she was in great pain near her chest. I looked at her and saw that she was not stabbed but sick. The next day she was so nice to me and was feeling fine. Ever since that time she was nice to me until her death. It's past now and it's fine with me. I was helped to survive. I used to feel so sorry the way my cousin was treated. I'm going to continue since I've started talking about it anyway.

My cousin used to cry when Ikuutaq forced her to go to bed with Aasivak because he didn't have a wife anymore. That is why Hattie [Aasivik's daughter] was born. She wouldn't have been born if my cousin had a say and was free to decide. My cousin cried when her clothes were taken off by Ikuutaq to go to bed with Aasivak. We were overpowered that time. She wouldn't have had a baby if she wasn't treated like that.

Tiktaalaaq went to get food in Baker Lake. Before he left he went to get Havaa [a member of Siksigaq's camp] so she would stay with me while he was

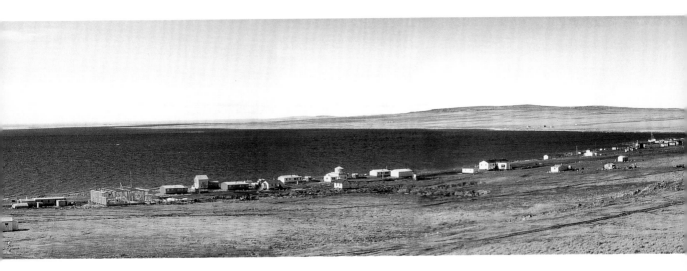

gone. There was no food around. There was a little bit of water though. I made cocoa, which fills you up more than tea and does not let you get nauseated. It turned out really good. Havaa and I were alone that spring. Ikuutaq arrived with cached meat from the land and gave us a shoulderblade of caribou which had maggots on it, but it seemed like so much food. It was a big thing for us. We caught a small fish and ate the middle part uncooked. Tiktaalaaq arrived from Baker Lake with some moose meat he got from the RCMP. He was given that and we were so happy.

In late January of 1950 photographer Richard Harrington traveled by dog team from Arviat on the Hudson Bay coast to the upper Kazan River area. He visited settlements of the Padlermiut (people of the willow thicket), who were in the vicinity of the Hudson's Bay Company post at Padlei. His powerful black and white photographs and his diary from January to April 1950 were published in 2000 under the title *Padlei Diary, 1950*. On 31 January 1950, he recorded a night-time temperature of -60 F. A week later he wrote,

February 8:
Came upon the tiniest igloo yet. Outside lay a single, mangy dog, motionless,

starving, sole survivor of a full team; a primus stove, half-drifted under; a broken *komatik* [sled]. Inside, a small woman [*Tetuk*] in clumsy clothes, large hood, with baby. She sat in darkness, without heat. She speaks to me. I believe she said they are starving.

Never before did the word cave-dwellers come to my mind, until I crawled into this small anteroom, bones strewn around, all sucked clean of marrow. [The anteroom] opened into a tiny lair, round, where I couldn't even stand upright. She hunched up there. No place for Kumok: he knelt in the anteroom. We brought in some biscuits, thermos bottles. She chewed bits of hardtack, then gave it to the baby, nice and soggy. Baby gurgled.

They were out of nearly everything. No matches, tea, kerosene. The first igloo I've seen without lamp or heat. We left some tea, matches, kerosene, biscuits. And went on.

Later we met [her] husband, [Annowtalik], a young man with a rifle and empty game bag. He started with 6 dogs, now has one.

…

As far as possible, they tried to continue their way of life. Those who had the strength to go out and gather firewood, had small fires going in their *tupiks* [skin tents].

A month later he writes,

Ahkpa came along. It soon started to blow. Team became wild when it smelled caribou. One ran cross-wind. Ahkpa fired at 200 yards. But it got away, though the dogs chased it as though they had no load behind.

For once we had tail winds. Only reason we continued. Four more caribou sighted, 6 shots brought down 2, both small. Dogs just dove in, tearing, ripping, before men could drive them off. Blood-smeared, fighting amongst themselves, always trying to get at the meat again. Though the caribou were dead, their exposed muscles still quivered. Here was food at last.

In the epilogue to his book Richard Harrington acknowledges that it was Henry Voisey, the manager of the Hudson's Bay Company post at Padlei, who

sent out the radio message: *starvation*. After Harrington returned to Toronto several of his photographs appeared in the Canadian press. He notes that,

> Other signals from the North followed. Clearly a tragedy was in progress, but over a year passed before its dimension and causes became clear.
>
> Ironically, America soon installed, in this very area, the world's most sophisticated electronic defense system (DEW line), yet communications with local Eskimos remained almost paleolithic.
>
> Before this tragedy was resolved, conditions worsened, culminating in headline tragedies.[8]

At the time of the Padlei tragedy, Avaalaaqiaq was living with Iksiktaaryunaaq's family. She was attempting to make the best of a difficult situation and contribute, as she was expected, to the communal search for food and the group's survival.

In the mid 1950s there was another serious famine that affected many Inuit families. The situation was worsened by the declining market for white fox furs when fashions changed after World War II. The Inuit could no longer produce sufficient barter power from their traplines to trade for the goods they had become dependent on, such as tea, sugar, flour, cloth, and ammunition. The severe decline in the caribou herds meant that the results of their hunting efforts were often below the subsistence level. A further stress was created by the increasing prevalence of Western society's diseases, which were causing illness and death.

Baker Lake artist Simon Tookoome recalls his experiences of the mid 1950s starvation period.

> In the winter of 1957 to 1958, the caribou took a different route to the calving grounds. We could not find them. All the animals were scarce. We were left waiting and many of the people died of hunger.
>
> My family did not suffer as much as others. None of us died. We kept moving and looking. We survived on fish. We had thirty dogs. All but four died but we only had to eat one of them. The rest we left behind. We did not feel it was right to eat them or feed them to the other dogs.
>
> My father and his brothers had gone ahead to hunt. We had lost a lot of

weight and were very hungry. I left the igloo and I knelt and prayed at a great rock. This was the first time I had ever prayed. Then five healthy caribou appeared on the ice and they did not run away. I thought I would not be able to catch them because there were no shadows. The land was flat without even a rock for cover. However, I was able to kill them with little effort. I was so grateful that I shook their hooves as a sign of gratitude because they gave themselves up to my hunger. I melted the snow with my mouth and gave them each a drink. I was careful in removing the sinews so as to ease their spirits' pain. This is the traditional way to show thanks. Because of what those caribou did, I always hunted in this way. I respected the animals.[9]

Another Baker Lake artist, William Noah, recounts in his memoir from the publication *Qamanittuaq: Where the River Widens* the rescue of his mother, the famous artist Jessie Oonark, and his sister Nancy Pukingrnak by the Royal Canadian Mounted Police. As a young teenager Noah walked to Baker Lake from his mother's camp to notify the authorities of their desperate situation. He states that they were "just barely alive and very hungry and cold." Oonark and Pukingrnak were brought to Baker Lake where they were joined by other family members. The Oonark family decided to take up permanent residency in Baker Lake.[10]

The settlement of Baker Lake had served as a trading centre for a widely dispersed group of Inuit since 1916, when the Hudson's Bay Company built a post at Uqpiktujuq or Big Hips Island. In 1926 the Hudson's Bay Company post was moved close to the present location of Baker Lake, near the mouth of the Thelon River: the Inuktitut name for Baker Lake, Qamanittuaq, means "where the river widens." Shortly after in 1927 the Anglican and Roman Catholic missions were established and missionaries were visiting outlying Inuit camps. In the 1950s the federal government responded to the starvation tragedy by establishing social services in Baker Lake and at other trading posts. Inuit were persuaded to abandon their nomadic ways to live in the settlements, where they would have access to medical services, store-bought food, and schooling for their children.

A nursing station was built in Baker Lake in 1957, a federal day school in 1957, and in 1962 pre-fabricated housing units were built by the Department of Northern Affairs and Natural Resources.[11] The majority of the Inuit families moved to

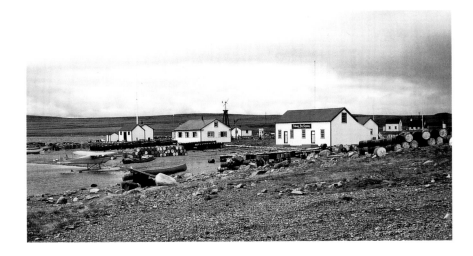

Hudson's Bay Company
buildings, Baker Lake, 1958

Baker Lake at this time; Simon Tookoome, like a few others, managed to main-
tain a subsistence lifestyle on the land until the mid 1960s, when he was forced to
move to Baker Lake so his son could attend school. After living for a period in the
vicinity of Baker Lake, Avaalaaqiaq and Tiktaalaaq decided to move to the settle-
ment in 1958. She explains the circumstances that brought them to Baker Lake.

In 1958 I developed some kind of pneumonia. We were camping on our way
to Baker Lake. I was lying in bed and Tiktaalaaq and I were facing each
other. I started coughing and kept on coughing. I couldn't move and I spat
on Tiktaalaaq's face. He quickly said, "Ah, what are you doing?" The cold was
making me cough.

The nurse at Baker Lake sent Winnie [a Baker Lake resident] and me out
to Churchill for a medical. This was my first time on a plane and it was a
small plane too. Winnie and I were very young and didn't have any children
yet. Winnie and I prayed in a bathroom wearing towels on our heads. We
could have just prayed anywhere without hiding. We weren't used to wearing
gowns and it was so embarrassing when you're not used to it. I was told that I
was going to Clearwater Lake (sanatorium). I looked up and saw people from
Baker Lake and they were on their way to Clearwater Lake also. At Clearwa-
ter Lake, Niviq (William Aupaluktuq's first wife) and I were together.

They placed us with Indians. We didn't undress for a long time and just sat on our beds. We were told to undress now. I didn't really have tuberculosis but was sent there. I was in labour and kept going to the bathroom. I didn't want them to know so I was trying to hide my labour. We were in a five-bed-room unit and my cousin said, "Are you feeling the contractions now?" I said, "No," because I didn't understand her. I wasn't informed about giving birth and what it would be like. The nurse checked me over and said that I was in labour and that I would have to be sent to The Pas. She told me to get dressed. I cried again, wanting to be with Inuit. We traveled for a whole hour going to The Pas and went to the nuns. The nuns had big hats on. After giv-ing birth I just left the baby. They would let me see the baby through a glass window but I used to wonder about it. I didn't know Nancy would be the one child that would be a great help to me. In the late fall I returned to Baker Lake.

Now that the family had decided to live permanently in the settlement, Avaalaaqiaq took a job as a house cleaner at the nursing station.

I used to leave Nancy with Qaqsauq when I went to the Nursing Station to pick up milk for my son. We were living in a tent right beside her small wooden house. When I took Nancy over to Qaqsauq's house she was not home, so I tied Nancy by her waist and anchored her to the bed and left her there. Qaqsauq [a Baker Lake resident] was surprised to see a baby tied up and started to scold me right away when I came back. I meekly replied, "I didn't want the baby to pick up anything so I tied her up." How dreadful it is. Good thing she didn't get strangled. What a stupid thing to do!

When I first moved to Baker Lake and saw an airplane, I was so scared. In the church we tried not to make any noises. We couldn't even smile. We couldn't even touch the walls of the church because the minister was very careful of things. We were told not to move so that we could listen to the ser-mon. We couldn't even turn out heads and we tried not to let our children make any noises. The children were not allowed to run around. Now in church, the people just talk and the children are running around. When a

child cried, Canon James would say to take the child out so that the people can hear properly. We were taught these things. Canon James was really concerned about the big church. I mean it looked like a big church at that time and everything looked so big. They seem small now though.

In the early years she was largely occupied with child rearing and the necessities of family life. Like many women in her generation she has a large family.

In 1960 I went out on medical for the second time and this time to Churchill. The years of 1958, 1959, 1960, 1961 I was bearing children. Nancy was born in 1958, Basil was born in 1959 and another one in 1960 and Itiblooie (Elizabeth) was born in 1961 and Norman was born in 1962 and in 1963 another girl named Mary Amarook was born who died after a few months. Peter was born in 1963. Another one that didn't live was born in 1965. Rita Jorah was born in 1966 but only lived a couple of months. My youngest daughter, Susan, was born in 1967. I also have two adopted children, Evelyn, who was born in 1974, and Marvin in 1976.

Avaalaaqiaq holding her son Basil Itulukatnaaq with her daughter Nancy Siksigaq, 1958

Her extended family comprises over thirty grandchildren, which brings its own special responsibility for a grandmother who is viewed both as a family leader and the significant provider. In certain instances it is the successful artists who are now bringing financial stability to extended families. This was traditionally the role of the hunter, who assumed a position of prominence and responsibility through the sharing of food. Now the purchasing power created by art sales is an important component of many family incomes in the North.

Around 1969 and 1970 I started carving out of soapstone. I was making miniature size carvings. One time I carved a ptarmigan with a human head on it. I took my carving to the Area Administrator and was so thrilled to receive money. I bought lots of groceries since they were cheap at that time.

When I first sold my wall hangings I bought a 340 Ski-Doo that cost $800. I was so thrilled I had bought something really big. I thought, "Now I'm really going to go fast and without having to walk around." At that time I loved to dance. Mrs Arngaqyuinnaq [a Baker Lake resident] gave me a pleated black skirt that was made out of a jersey-like material. I put my dress on to go to the dance. The dance hall was close by. I could have just walked, but I went by Ski-Doo. When I pulled the cord to start the machine my skirt got caught in the carburetor. It sucked in my skirt and ripped it. I was so disappointed.

Ironically, considering she would make fabric and embroidery floss her chosen medium, she said that she had great difficulty learning to sew.

I used to have a hard time sewing because I was never taught to sew. I still don't know how to make a pair of *kamiks* (caribou skin boots) and an outfit of caribou skin. Tiktaalaaq and I would try to make a parka out of caribou skin using a jacket for a pattern. It was hard for me, so Tiktaalaaq and I never did have any good clothing because of my incapability to sew.

We somehow survived in wooden houses. When we first got a wooden house it seemed so huge. It had big windows and it made you want to turn your head to see when someone walked by. It was warm too. Later we got

another house with three bedrooms. When you first start getting things you care for them with a passion.

Those Inuit who had moved to the settlements now had to learn to operate within the framework of a cash economy, rather than obtaining their goods through trade. This was difficult at a time when there were few opportunities for actual employment. The federal government sought to alleviate their reliance on subsidy by developing "arts industries," which were designed to build on traditional skills for making objects.

The marketing of stone sculpture from the Eastern Arctic began in 1948 when James Houston, the manager of the West Baffin Eskimo Cooperative in Cape Dorset, collected pieces from settlements on the east coast of Hudson Bay. The sale of these sculptures in Montreal led to Houston receiving sponsorship from the Canadian Guild of Crafts in Montreal and from the federal government to launch a stone carving program. From his headquarters on Baffin Island, he visited every Canadian Eastern Arctic settlement to see what progress was being made by various artists who lived thousands of miles apart.[12] These initiatives resulted in the successful marketing of carvings from Baffin Island and from the east coast of Hudson Bay in Montreal and other Canadian cities. The introduction of annual print collections at Cape Dorset and in other Eastern Arctic communities in the 1960s also resulted in a favourable response from southern buyers, as art dealers and some public galleries began to arrange exhibitions of prints and carvings.

The success of the art making programs in the Eastern Arctic region encouraged similar activities at Baker Lake. A government-sponsored craft program was established in 1963 under the direction of Gabriel Gély to develop soapstone carving, sewing projects, and jewellery and tapestry making.[13] Elizabeth Whitton, who was married to the Anglican missionary at the time, wrote about the 1963–65 period when Gély was craft officer.

[… Gély … discovered…] tremendous potential in this almost taken-for-granted ability of the ladies to sew, and create pictures with their needles. Introduced at this stage to a treasure trove of gaily coloured wools and

embroidery silks the ladies experimented freely. Some of them found that they needed a framework in which to express ideas and so the first wall hangings evolved. As the older people had not had the advantages of paper, pencils and colours with which to put down their thoughts, these first attempts were disjointed and the cutting of appliqué shapes somewhat stereotyped ... At the same time drawing and printmaking had begun and many people were fascinated by being able to express old legends, scenes from their way of life, in various media.[14]

During the 1960s there were also some early attempts to initiate a graphics program in Baker Lake, which involved introducing a number of individuals to drawing. For many of the older residents it was their first experience of using Western art making techniques and materials.

The remarkable drawings that began to be produced by people working in their homes became the basis of a very successful printmaking program, which launched its first annual collection in 1970. American artists Jack Butler and Sheila Butler, who arrived as craft officers in 1969, provided the direction and expertise to produce the first collection. They revived the practice of purchasing drawings and offered payment to those Inuit who were interested in learning printmaking. The result was a collection of thirty-one prints featuring stone cuts and stencil printing.[15] The graphic arts program was flourishing by the early 1970s. At the same time a number of women were making small stitched and appliquéd pictures that they called *neevingatah*, meaning "something to hang." These textile pictures, created with wool fabric and cotton embroidery thread, became known as wall hangings.

In reporting on the first three years of the Butlers' tenure as craft officers, Sheila Butler commented,

As the number and quality of these small hangings grew, we wanted to provide better materials, and particularly some larger pieces of fabric for backing to give enlarged scope to some of the breathtaking designs. When the garment sewing factory closed, much of the inventory of fabric had been stored in the upstairs loft of the Craft Shop. So, using melton cloth or the light-

weight wool fabric called stroud, we cut larger backing sizes and smaller pieces to be used for cutting figures. We gave this cloth, along with several colours of embroidery floss, to the most promising of the wall hanging artists. The use of new large pieces of cloth rather than scraps, expanded the creative possibilities and heightened everyone's enthusiasm. We gave little in the way of aesthetic criticism but simply suggested that maybe a decorative border could be added, or more in the way of decorative stitching.[16]

It was within this exciting milieu of art making activities that Avaalaaqiaq, with her youngest child aged three, became intrigued, and eager to participate. She recalls her first attempt at creating a sewn image around 1969–70.

I started thinking that I should draw something to show people what my grandmother used to talk about. There was a piece of white cloth and it was the size of a piece of short paper. At that time the Arts and Crafts programs were just starting to operate. I was thinking of a story my grandmother told me, so I drew a ptarmigan with human heads on it. She said that animals used to transform into humans and there were caribou that were called *iyiraq*. With a black pencil I made an outline on the cloth. At that time there wasn't even embroidery threads available. I used a black thread to sew it. I presented it to the Area Administrator for him to see. Of course he was surprised to see a ptarmigan with human heads on it. He said, "Show it to the arts and crafts officer and probably something will come of it."

The craft officers (Jack Butler and Sheila Butler) said I should do one exactly the same but make it out of duffle. The material seemed so big and I wondered how I was going to fill out all the empty space. I was thrilled that I was requested to make one. I just put only a few items on it. I was asked what are those images. I replied, "They are stories my grandmother used to tell me in the evening. I did them out of memory." Since that time my wall hangings have been getting bigger and bigger to this day. I've been making wall hangings ever since but I stopped making them for a year or two because there was no craft officer. I was happy to be recognized for the art work I do. I thought that maybe someday they would be displayed.

Irene Avaalaaqiaq, 1990

In 1971 Jack Butler and Sheila Butler, with the assistance of a loan from the federal Eskimo Loan Fund, helped establish a cooperative called Sanavik, which means "open workshop." The purpose of the cooperative was to foster and coordinate art making activities. Other cooperatives, such as Cape Dorset's West Baffin Eskimo Cooperative, had been remarkably successful as organizational structures to guide the production and marketing of art. In 1972 the Butlers left Baker Lake, but they continued as consultants until 1976, advising the Sanavik printmakers on the production of the annual print collections.[17] The graphics were selling well as the dealer network grew and Inuit art became more popular and widely recognized.

Avaalaaqiaq made her debut in the 1975 annual collection with two prints, *Human Water Worms* and *The Big Head with Horns*. She printed both stencil prints herself, which was unusual since the custom in Inuit printmaking is for a

drawing to be done by one artist and its interpretation into a printmaking medium by another. In the case of a stone cut, as is the practice in Cape Dorset, a third person is often involved in the cutting of a relief image into a large soapstone block to prepare it for inking by the printer. Avaalaaqiaq's technique was to make small adjustments with the stencil as she interpreted her original drawing into the print medium. The grainy character of the stencil printing was particularly well suited for her drawings. The graininess simulated the delicate tonal areas of her drawings, which she created by carefully filling in shapes with the edge of a coloured pencil, as is evident in the print *The Shaman Calls His Friends*, 1980 (plate 4). Her use of rounded forms to depict human and animal transformations is also evident in wall hangings from this period, such as *Happy Spring Has Returned*, 1981 (plate 5).

The printmaking program faced a serious setback in 1977, as the 1978 Baker Lake catalogue related.

> In 1977 a fire leveled the Sanavik Co-op building destroying the partially completed 1978 print collection, the print stones and the archives of hundreds of drawings which had been compiled as a compendium of possible images for future print collections. With help from various government and other sources, the artists under advisor John Evans worked to reinstate the collection and because of time constraints and the lack of sufficient print stones, linocuts were introduced into the 1978 collection.[18]

Avaalaaqiaq contributed a linocut to this collection, but found that the linear character of the linocut medium did not offer the expansiveness of the stencil technique in which she could create large flowing forms. During the 1970s and 1980s, she contributed mostly stencil prints to the collections and served as printer for other artists for several prints. In 1990 Sanavik launched its first independently produced print collection. Shortly after, however, the program was suspended by the cooperative owing to technical and financial problems. In the late 1990s the Baker Lake print collections were revived under the auspices of Arctic College and later under the Nunavut government. Avaalaaqiaq decided to stop participating in the annual print collections and focus on her wall hangings.

PLATE 4
The Shaman Calls His Friends, 1980, stencil print

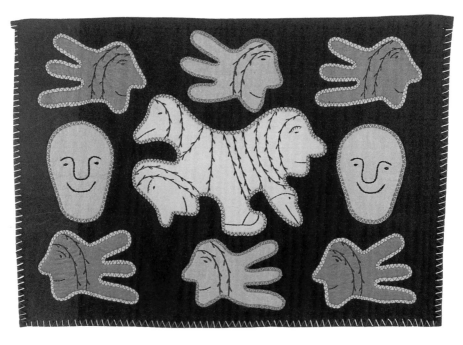

PLATE 5
Happy Spring Has Returned, 1981, wool felt, cotton embroidery thread

While she was engaged with drawing and printmaking she was developing her skill as a wall hanging artist. The wall hanging *Mysterious Powers of the Shaman*, 1974 (plate 6) shows characteristics that would become hallmarks of her style – transformation subjects, an animated border, and brilliant colours. During the 1970s she received commissions for a public building in Ottawa and for the state legislature in Minneapolis. The most significant commission was the 1975 wall hanging *Untitled*, 1975 (plate 7), for the Town Centre Complex in Churchill, Manitoba. This massive 310 cm x 150 cm work was executed in three horizontal bands, each depicting a row of transformation subjects.

Over the past thirty years, more than fifty women have participated in the sewing program in Baker Lake. Twelve of these artists were recognized in a touring exhibition of wall hangings titled *Northern Lights: Inuit Textile Art from the Canadian Arctic*, which was organized in 1994 by The Baltimore Museum of Art.

Among the featured artists were Jessie Oonark (1906–1985) and four of her daughters, Janet Kigusiuq, Victoria Mamnguqsualuk, Miriam Qiyuk, and Mary Yuusipik. Also represented were Martha Qarliksaq and her sister Naomi Ityi, as well as Elizabeth Angrnaqquaq, Winnie Tatya, Marion Tuu'luq, and Ruth Qaulluaryuk, all artists who grew up in the Back River/Garry Lake area, about 200 kilometres northwest of Baker Lake. The twelfth artist was Irene Avaalaaqiaq. All

Avaalaaqiaq working on her print *The Big Head with Horns*, 1975

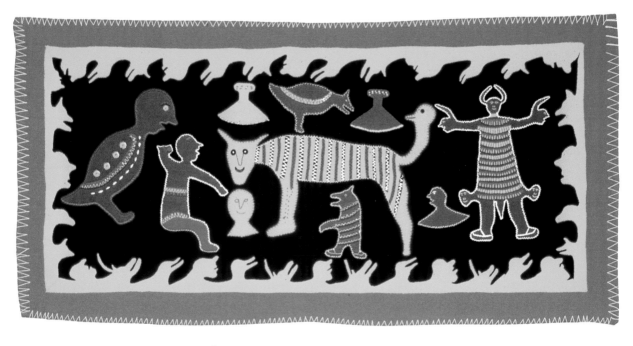

PLATE 6
Mysterious Powers of the Shaman, 1974
wool duffle and felt, cotton embroidery thread

PLATE 7
Untitled, 1975
wool duffle and felt, cotton
embroidery thread

of these women, like Avaalaaqaiq, lived the traditional life on the land until the late 1950s when severe starvation forced many to move to Baker Lake. They have used their finely honed sewing skills as a means of supplementing family income, by making fabric pictures from scraps left over from parka-sewing projects.

With the availability of large pieces of duffle and felt cloth and different colours of cotton embroidery floss, the artists extended the inset fur designs used in the decoration of caribou parkas to this new form of picture making. From the beginning each artist exhibited a distinctive style and approach to image making. Jessie Oonark, one of the most highly recognized Inuit artists, displayed her innate design sense through majestic and emblematic images that were highly abstracted. Oonark's daughters took a more narrative approach when depicting family relationships, camp scenes, legends, and scenes of shamanic intervention. Other artists like Elizabeth Angrnaqquaq and Miriam Qiyuk expressed an interest in realistic depiction by producing densely embroidered animals that were anatomically correct, with the stitches imitating the animals' fur. Anita Jones, co-curator of the *Northern Lights* exhibition, noted that a number of artists developed their own stitches outside the canon of European embroidery.[19] For instance, Avaalaaqiaq uses her distinctive branching chain stitch to add content such as sunbeams or gentle twigs of arctic willow. The word *Avaalaaqiaq* in Inuktitut means "willow," making this unusual stitch her symbolic signature. The stitch also signifies her powerful attachment to the land and its nurturing powers that she relied on in the early years of her life.

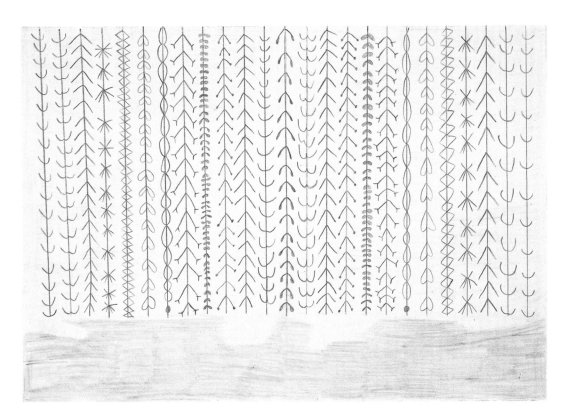

PLATE 8
Willow Bushes, 1970s
graphite and coloured pencil on paper

In the drawing *Willow Bushes*, 1970s (plate 8), she creates a diagrammatic summary of a yearly growth cycle. Through a series of repeated vertical lines that look remarkably like embroidery stitches, she depicts an abstraction of plants: the lines with the arrows going up are the plants in the spring, alive, and the ones going down are the dead plants in the fall. The spring and fall cycle is represented in the band at the bottom of the drawing, with blue being the water in springtime and the white indicating snow. Her experience of the tundra as a hunter and of living many years on the land is summarized in this lean abstracted statement. It also depicts the timelessness of nature as viewed by hunting peoples who experience the seemingly endless cycling and recycling of the landscape.

When Rasmussen and Birket-Smith visited the Caribou Inuit of the Barren Grounds during the winter and spring of 1922, they found design motifs similar to Avaalaaqiaq's *Willow Bushes*. Birket-Smith analysed the use of decoration among the Caribou Inuit. Except for the richly embroidered female *atigi* (inner parkas), he found little evidence of decoration. The embroidery of the *atigi* was executed in brightly coloured glass beads obtained through trade. These decorated *atigi* continue to be made today by women for wearing at festive occasions such as weddings. The embroidery reveals a fondness for repetition and the use of straight and curved lines, zigzags, circles, triangles, stripes, and double curves. Birket-Smith identified the most common of all the patterns as "framing with lines."[20]

Birket-Smith collected an embroidered cloth bag in 1922 in the upper Kazan River area. The bag, which Birket-Smith described as being "very old," has design motifs that could be considered antecedent to those on Avaalaaqiaq's wall hangings and drawings. The cloth bag terminates in five finger shapes and is completely surrounded by a border formed by a line of embroidery. The bag is also decorated with lines of vertical embroidery with simple double-curves like fish hooks or leaves. This motif is remarkably similar to Avaalaaqiaq's willow stitch and her abstraction of plants in the drawing *Willow Bushes*. In her wall hangings, Avaalaaqiaq has developed the concept of a simple framing pattern into fully developed borders that are appliquéd with prominent zigzag stitches.

Avaalaaqiaq's preference for brilliant contrasting hues arises from her perceptive and intuitive understanding of colour theory. It is also linked to the tradition of using brilliant primary colours in the *atigi* embroideries. Her spare use of

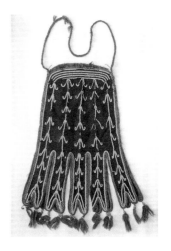

Cloth bag with beaded embroidery collected by ethnologist Kaj Birket-Smith in the upper Kazan River area in 1922.

PLATE 9
All Different Thoughts, 1978
stencil print

embroidery thread is used like a drawn line, adding details to animate her extraordinary creatures.

In 1922 Birket-Smith also found a Harvaqtormiut kayak that had a painting of a caribou on its deck, where it served a magical purpose for the hunt. The simple round shape of the caribou was drawn in ochre and fat, which were also used to fill in the outline of the abstracted design.[21]

Avaalaaqiaq exhibits a similar preference for flowing, rounded forms in her wall hangings and drawings. As these forms coalesce they suggest the enduring forces of nature and the spiritual union of humans and animals that is central to an animistic world view.

In the stencil print *All Different Thoughts,* 1978 (plate 9), a repetition of rounded forms depicts the evolving thought process of a person. The green head on the left is a human who is remembering a goose that spoke and a wolf that he fears. Avaalaaqiaq records the memory by showing the human head, goose, and wolf transforming into one image. The artist states that this human was forced at one time to eat human flesh because of starvation. The human head/goose/wolf image is repeated eight times with variations receding in size towards the right.

PLATE 10
Imagination Visions, 1980s
coloured pencil on paper

Avaalaaqiaq explains that at first we remember things clearly and over time our memory fades, but horrifying and regretful incidents will never leave us.

Avaalaaqiaq's ability to combine multiple ideas into a single graphic image is also evident in *Imagination Visions*, 1980s (plate 10). This drawing portrays a hunter on the land alone at night. The transforming creature in the centre is a visualization of the hunter's thoughts.

> It is kind of scary sometimes – imagination. The thing is not really there but you think you see it. As soon as it gets dark when I am out hunting or camping I get really scared.

In this drawing Avaalaaqiaq uses a double head to indicate that the same person is thinking and looking both ways. The device of using a double face to show a person thinking also appears in other Baker Lake artists' work, such as that of Simon Tookoome. The green line around the double head represents the land-

scape and the blue line the sky. With these lines she abstracts the 360-degree horizon into a border to symbolize the hunter's view of the treeless tundra, where the willow thicket grows low and plentiful during the summer. She draws her willow embroidery stitch to depict the plants and to add her symbolic signature. Although Avaalaaqiaq also signs her name in Inuktitut using syllabic characters, the willow signature motif serves as a metaphor for her identity. The willow thicket reminds her of her homeland, her loving grandmother who raised her, and the loss of the ancient culture associated with her homeland. The power of this signature motif is evident in the wall hanging *Young Man Out Walking*, 1989 (plate 1), where the leaves form a protective screen to ward off danger and the same stitch indicates blood coursing through the young man's veins.

The Inuit who lived out on the land in the traditional camps believed the tundra landscape would always provide, while at the same time they respected its dangers. Knowledge of the land and its geographical formations, of weather patterns, and of the course of action to take in times of danger were crucial for survival when unexpected weather changes could create perilous situations.

Rasmussen commented on the physiography of the tundra, which is covered with lichens and bush heath. It turns into a meadow or lush willow thicket at times of moisture. In summer the tundra becomes a richly coloured mat as small plants burst into bloom.

I draw attention to how extremely difficult it was to find our way on the Barren Grounds. The one part resembled the other, and as soon as we got a little way from the main channel of Kazan River, we ran as a rule into a net of small watercourses which wound their way between large and small lakes and made it difficult to keep the set course. The very gneiss hills resembled each other, and only when one had very definite land marks and bearings to go upon, could one be distinguished from the other. The Caribou Eskimos, however, have such marks in abundance, and they had also to a great extent given the land names, as a rule characteristic and informative names, the result being that to one who was familiar with these names it was not so difficult to find the way.[22]

In the early years of her marriage Avaalaaqiaq and her husband had a frightening experience while hunting:

One day before we had children, my husband Tiktaalaaq and I got lost when we were out hunting. When you get lost on a very nice day you get lost completely and don't know where to go. After Tiktaalaaq finished loading the *qamutik* (sled) he said, "On our way to Baker Lake we'll remove the traps and I'll go ahead of you and will lead the way to get closer to Baker Lake." I packed up to go while he went ahead. Shortly after a storm broke out and we got separated. Tiktaalaaq only had a snow knife and I had everything with me because I was going by dog team. A long time ago the dogs knew the way and they were very knowledgeable. Tiktaalaaq was walking for a long time. The dogs were following his trail and I couldn't even see my lead dog because of the storm. The wind was coming from the East and was really blowing hard. My dogs couldn't walk any further. I went down the slope right near the river at Anitguq. Luckily I didn't fall right into the river. I camped on a smooth part of the land. I shoveled the snow in to make a shelter. I didn't even tie down the dogs because of the storm but made sure they were anchored properly. I shoveled a hole right beside the *qamutik* and placed a caribou skin on the entrance. I just lay down without drinking any tea. I was afraid and didn't know where Tiktaalaaq was. I also didn't know the way to Baker Lake. The next day it was really nice out. While I was tying up the load the dogs were really eager to go and trying to pull away. I started thinking maybe they know where Tiktaalaaq is. I started going down the hill and there he was walking. Before I saw him I was thinking if I don't see him I would go and ask the minister to help find him. We met together. He said that he didn't know where he was too.

Like many Baker Lake residents Avaalaaqiaq spends as much time as possible "on the land." She is an accomplished hunter and is a member of the Baker Lake Rangers, a group that rescues people who have lost their way while hunting or camping. In 1999 she participated in the rescue of her friend and art dealer Sally

Qimmiu'naaq Webster and other Baker Lake residents who had become marooned by a life-threatening blizzard while winter camping. Her other community activities include active involvement in a food bank that she and Susan Toolooktook established in the early 1990s. This service also collects and distributes clothing for the benefit of the community.

In her early sixties, Avaalaaqiaq is one of only a few Baker Lake women who actively hunt caribou. She prefers to hunt alone and often stays out all night traveling by snowmobile. She will load a small carcass onto her sled, but a larger one (a bull caribou is the size of a small horse) is butchered on the land before being transported home to be shared with her large family. The sale of her art allows her to help satisfy her family's desire for "country food," store-bought groceries, and luxury items. She brings a similar commitment and intensity to her art work, explaining that in early years she would work continuously, day and night, to complete a wall hanging. Now it takes approximately three days and she sometimes engages her daughters to assist with the long rows of zigzag back stitching that bind the edges of the hangings and to tack down the appliqué shapes that she cuts out freehand without working from a sketch. She works quickly and does not aim for a high level of sewing proficiency; this contributes to a freer style and allows her to push the boundaries of her creativity.

Baker Lake Rangers, June 1999. Avaalaaqiaq is on the far right, wearing a life jacket, with The Right Honourable Roméo LeBlanc, CC, CMM, CD, and Mrs Diana Fowler LeBlanc during the opening of festivities for Itsarnittakarvik: Inuit Heritage Centre.

In her convocation address Avaalaaqiaq noted, "If Inuit did not learn well, they would not survive in the harsh climate. We had to learn in order to live. The father taught boys how to hunt and the mother would teach the girls to sew. Now times have changed and a lot of women hunt but the men have still not learned to sew too well."

During the summer of 1999 Avaalaaqiaq made a special series of three wall hangings and six coloured pencil drawings commissioned by the Macdonald Stewart Art Centre. The commission acknowledged the conferring of an honorary degree on Avaalaaqiaq by the University of Guelph in October 1999. Of these wall hangings she has indicated that *Husband and Wife,* 1999 (plate 11) is her favourite. This portrait of a husband and wife is particularly poignant for the artist, since her husband Tiktaalaaq died in 1999.

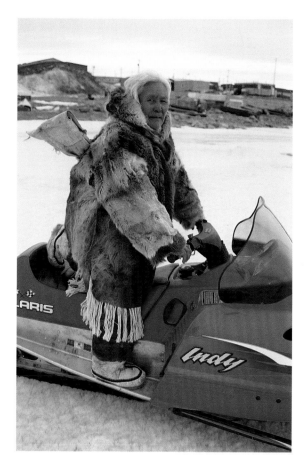

Avaalaaqiaq on her snowmobile with her caribou hunting gear, 2001

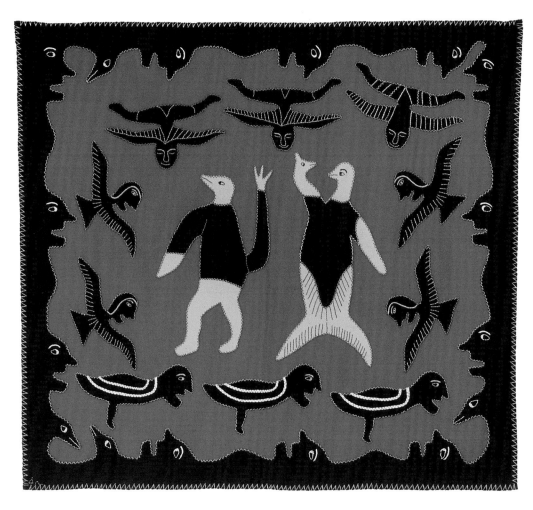

PLATE II
Husband and Wife, 1999
wool duffle and felt, cotton embroidery thread

Sometimes when a husband and wife are walking on the tundra, it is so quiet. Sometimes if they are not talking to each other, the husband will try to make his wife jump or the wife will try to make her husband jump, for fun, jokingly.

As in the drawing *Imagination Visions,* 1980s (plate 10), she depicts the frightening experience of nightfall on the land by compressing the horizon into an abstracted border. The black border signifies dusk, with the rocks transforming into human heads. The husband undertakes a transformation by changing his head into a goose. The wife responds by turning her head into a ptarmigan, her arm into a wolf, and her body into a fish. She calls out to the ravens to help them. The ravens develop human heads and fly down to assist.

A second wall hanging that is part of the Macdonald Stewart Art Centre-commissioned works is *Woman Alone,* 1999 (plate 12). In this work the border bursts forth with geese and wolves emerging from the dusk. At the centre is a woman who is alone, gathering moss and firewood, just as Avaalaaqiaq did in her youth. The woman thinks she is with two female companions, but they transform into shamans by assuming wolves' heads. These shamans are accompanied by their helping spirits in the form of human-headed birds and fish who are trying to attack the woman. Terrified, the woman is trying to escape. Avaalaaqiaq called the woman "three legs" because, she explained, when you look at a person running you can actually see three legs. The running woman sprouts wings and flies away.

Transformation subjects, spirit imagery, and shamanic performance are predominant themes in her work. Traditional Inuit mythology describes a dual reality of a physical and spiritual presence in all things, the ability for humans and animals to be one, and the ability of the shaman to intervene. Although she draws deeply on the old mythology for subject matter, she explains, "I don't experience the traditional religion very much. It doesn't play much of a part in my life." She does, however, relate experiences that have deeply affected her, such as seeing an *iyiraq,* a caribou that can speak like a human.

When I was a child sick with measles I wasn't fully conscious and I don't really know what was wrong with me. I was being licked. It was a dog that was

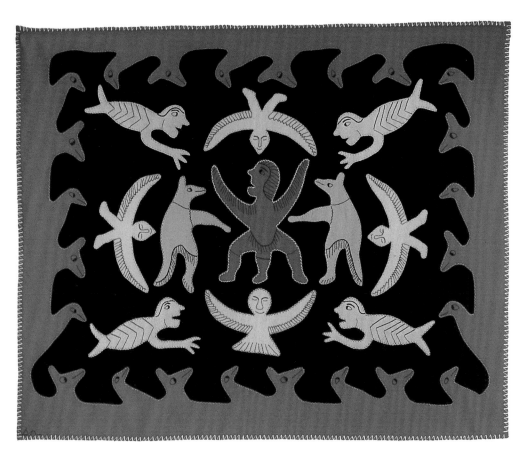

PLATE 12
Woman Alone, 1999
wool duffle and felt, cotton embroidery thread

licking me. It was his spirit. I went back to sleep and woke up again and the dog was gone. I saw his spirit in dog form and it was a really skinny dog. It seemed to have a white harness on. My uncle and I tried to run away and our dogs were barking too.

Not long ago Nancy and I were hunting and we saw a caribou. I shot twenty bullets at it and I am a good shot. We couldn't kill it. I'm sure it was an *iyiraq*.

Avaalaaqiaq's daughter was eighteen when they met this caribou in 1993.

My son and daughter Evelyn went out to hunt. We saw two caribou, and shot the first one, but we couldn't shoot the second. Some caribou just won't die. I asked my son how many more bullets we had and he said six. So I got really scared. This caribou walked all around us in a circle, and then came back to where it started. Caribou don't look back to where they came from. So I knew this was one that we shouldn't kill. Some caribou are human. You can tell by their legs. When they grow new fur it is very thin. This one was very thick. So we went back to the camp.[23]

These kinds of otherworldly incidents inform much of Avaalaaqiaq's imagery. In works such as the drawing *Shaman Hunting Caribou*, 1999 (plate 13), she depicts a forked-chin shaman swooping down upon human-headed caribou. She comments: "I can draw a magical caribou on paper, but I can't really do one on a wall hanging. It would not look the way I want it to because perspective on a wall hanging is harder than on paper." Rasmussen records a traditional story about a talking caribou. In the story, the caribou swims out into the river and meets a hunter in a kayak. The caribou saves itself by persuading the hunter to wait until autumn before he kills it, because his wife would then have fine rich suet.[24]

Traditionally the Caribou Inuit believed that their shamans occupied themselves with healing people of bodily diseases, rescuing people from the evil of other people, and the magic arts.[25] The wall hanging *Spirit Figures*, 1993 (plate 14) shows two young boys who are shaman initiates. Both have huge speaking faces emerging from their torsos and the boys are attempting to transform into geese to

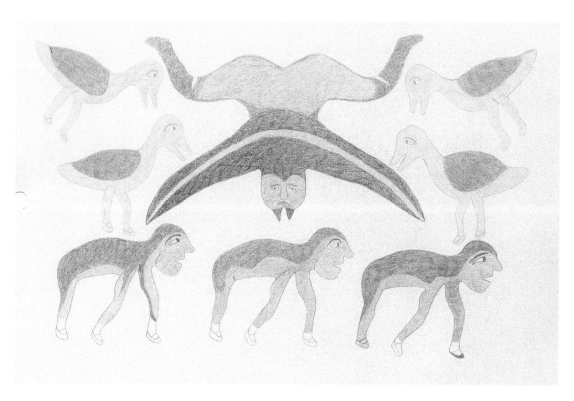

PLATE 13
Shaman Hunting Caribou, 1999
coloured pencil on paper

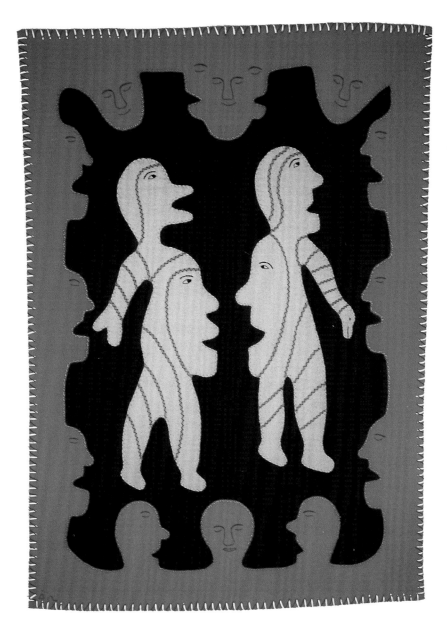

PLATE 14
Spirit Figures, 1993
wool duffle and felt, cotton embroidery thread

escape. Avaalaaqiaq comments, "The boys are cousins. This is a true story but since it's on a wall hanging it's hard to believe and understand."

These cousins were told not to go out after dark, the implication being that something horrible might happen to them if they did. The wall hanging works on a moral level much like the story of Hansel and Gretel: a mechanism to teach children through easily remembered tales. Avaalaaqiaq lives within a culture where there is a strong presence of Christianity to which she is personally committed, but where the magical mythology of the traditional life still exists within the collective consciousness.

The third wall hanging in the Macdonald Stewart Art Centre commission, *Human Becomes Wolf,* 1999 (plate 15), also expresses a warning about not taking due precaution. In this case, the central figure has transformed into a wolf. At sundown the wolf creature announces that the twelve yellow heads displayed around him are the people he ate. The border is made up of birds and humans who are terrified by this pronouncement.

In these works themes of being alone on the land, escape from danger, and the mystery and foreboding of nightfall mirror the uncertainties in Avaalaaqiaq's life and the frightening experiences she had as a child. Images of flight often appear in her work, referring to a prominent attribute of the shaman and to the bird as a helping spirit, and signifying bird attributes of freedom, escape, and the gaining of wisdom.

My grandmother told me about the human person who was flying up in the air and looking down and was so happy. Birds and geese are my favourite animals.

She has made small stone carvings of human-headed birds, and this image crops up, almost like a signature, in many of her works. It appears in a number of variations, such as the bird whose feathers metamorphose into human hands or the bird that becomes a fish with a human head. This latter image is from a story known throughout the Arctic. Avaalaaqiaq heard this story as a child and there is also a song about it.

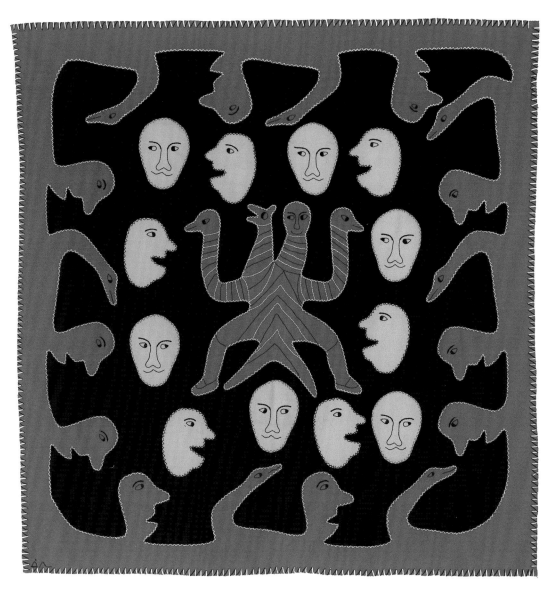

PLATE 15
Human Becomes Wolf, 1999
wool duffle and felt, cotton embroidery thread

The giant fish came along and swallowed the person and as the person was being swallowed, the person turned into a bird or maybe a fish.

In her sculpture she has created animal/human composite images, including a dog-like creature whose human face has long fetching eyelashes. She explains:

The stories my grandmother told me are from the time when animals used to talk like human beings … They stopped talking not very long ago.[26]

My grandmother used to tell me about how an animal could turn into a man and a man could turn into an animal. In one story, a walrus traded his tusks for a musk ox's horns. The musk ox said – "it is no good trying to eat grass with tusks!" The stories used to be true. I remember these stories and put them into my wall hangings. If I started working on a wall hanging in the morning, I will work all day and all evening until my eyes are tired and start again first thing the next morning and continue in this manner until it is completed. If I leave the wall hanging for too long, I get lazy.[27]

She is an intensely prolific artist who works quickly and lets her imagery emerge as she makes the wall hanging or drawing. She has developed an economy of means by thinking in terms of flat shapes. She either appliqués onto a contrasting background in the case of a wall hanging, or fills in a shape with the edge of a coloured pencil in the case of a drawing. She does not work from sketches, but will occasionally use a large piece of paper as an aid to draw an image before transferring it to fabric.

Her early wall hangings from the 1970s and early 1980s were often organized as rows of single figures surrounded with a simple border of blanket stitches. An example is *Happy Spring Has Returned*, 1981 (plate 5). In this work a felt binding of contrasting colour attaches the appliquéd images to the background.

The figures are happy that spring has arrived and the central figure is transforming into humans and birds. Six of the heads around him couldn't fly because their hair was too stiff. The other heads said, "At least you have hair; we lost our hair because the sun was too bright." The central figure replied, "I am happy I never lost my body, but I am about to develop a bird head."

During the mid 1980s and 1990s she began using centralized imagery as the focus of the wall hanging, with secondary creatures interacting with the central motif. At the same time large shapes of contrasting colours simplified the composition and increased its overall dramatic impact. Compositions are often symmetrical with fully developed borders that add narrative content. In wall hangings such as *Inukpak: Giant Person Who Eats Hands*, 1992 (plate 16), the border imagery is developed on both sides. In this work human hands and heads are combined with animal heads that emerge from both sides of the border. Avaalaaqiaq explains this wall hanging:

> The guy was hungry and he ate some things including a hand. The other hands grew up out of the ground [the border] and started to turn into people. He was scared and grew four legs so he could run away faster. He wished he had wings to fly away, so he started changing into a goose.[28]

Avaalaaqiaq creates a second powerful portrait in *Giant Transforming*, 2000 (plate 17) using the colours red and yellow. In this wall hanging the giant woman's hands are changing into birds and human faces sprout from her hips. She escapes the threatening red heads in the border by flying away.

There are a number of traditional stories about giants. One is a Caribou Inuit tale about Inukpak, recorded by Rasmussen in 1922. In this story the giant captures a hunter and because the hunter is so small, the giant tucks him away under the lace of his *kamik*.[29]

Rasmussen recorded another story about "The giant that fell in love with a human being."

> There was once a giant so tall that it used to wade out into the sea to catch walrus with its hands. The giant was a mighty sleeper, and when it lay down on the ground and went to sleep, the plants of the earth grew up over it, and ordinary womenfolk would go gathering fuel without knowing they were walking over a live giant lying there asleep.
>
> Once this giant fell in love with a woman, and asked her husband to change wives with him. And so they did. But it turned out in this way, that the man who was to lie with the giantess fell down into her genitals, was lost

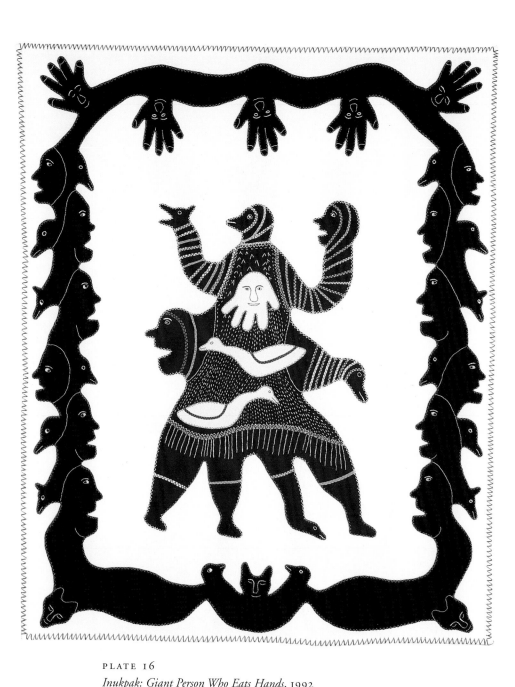

PLATE 16
Inukpak: Giant Person Who Eats Hands, 1992
wool duffle and felt, cotton embroidery thread

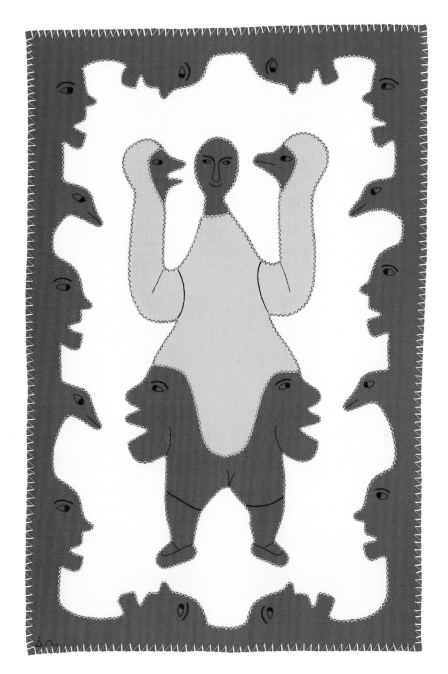

PLATE 17
Giant Transforming, 2000
wool duffle and felt, cotton embroidery thread

to sight, and perished. But the giant that was to lie with the woman, thrust his great penis right through her and she died.[30]

According to traditional beliefs, when humans and animals lost the ability to communicate directly, the shaman became the intermediary between the real world and the spiritual realm. In times past it was believed that the shaman could transform himself into any animal and assume flight to intervene on behalf of humans pleading for a successful hunt, relief of sickness and starvation, or the successful outcome of an human endeavour. According to the coastal Inuit the shaman would conduct seances using a beating drum and magical equipment. Seance participants were intensely involved as the shaman took mythical flight, assisted by helping spirits that could in their own right become visually manifest as animals or birds. For the coastal Inuit the shaman might visit Sedna, goddess of the sea, to placate her anger by combing and braiding her hair in exchange for allowing the sea mammals and fish to be consumed. Hunters were mindful of taboos associated with the hunt and performed special ceremonies to placate spirits when animals were taken. Shamanic initiation was lengthy and secretive as this special ability was taught to designated individuals.[31] These powerful traditions are at the root of Avaalaaqiaq's culture and appear as dominant subjects in her art. The great Baker Lake artist Jessie Oonark once speculated that "perhaps Irene was a shaman."[32]

In the drawings *The Helping Birds*, 1999 (plate 19) and *Flying Away*, 1999 (plate 20), flight becomes the mechanism of escape. Darlene Coward Wight has observed that in many Inuit artists' work there is a close association of women with birds, in particular stories about women turning into birds to save themselves.[33]

In a traditional fable children who are building a stone wall are frightened by a woman who claps her hands loudly. The children transform into willow grouse to escape, and become the original of all willow grouse.[34]

The bird transformation theme also appears in the Qiviuq stories, which are known across the Arctic. The hero, Qiviuq, is a trickster who becomes involved in various exploits, one of which is his goal of acquiring a bird wife. Although Qiviuq is a popular subject among fellow Baker Lake artists like Victoria Mamnguqsualuk and Miriam Qiyuk, Avaalaaqiaq has never illustrated these stories. Maria Colakovic discusses the Qiviuq story as a series of loosely knit tales that

are partly remembered and unstructured to the extent that they can change in the telling from one community to another or by an individual from one occasion to another. The fluidity of storytelling is a characteristic of an oral tradition and becomes even more so when the story is illustrated. Avaalaaqiaq illustrates the remembered stories of her grandmother, but in the telling these stories become very much her own. She will often depict the same story a number of times, but always with variations and with a different anecdotal emphasis drawn from the narrative. Avaalaaqiaq does not comment on contemporary life as some of the other wall hanging artists do; Miriam Qiyuk, for example, has sewn detailed serial imagery documenting the major events in her life and important family events such as her 1996 trip with relatives and friends to their birthplace on the Back River.

Many of Avaalaaqiaq's works show the sky and natural phenomenon such as the rainbow, which appears as a stylized arch in the drawing *Helping Birds*, 1999 (plate 19). The rainbow is abstracted even further in the wall hanging *The Rainbow*, 1994 (plate 22) by being depicted as a white, square-cornered arch that is transforming into human heads and birds. The border design is of human heads and hands, which signify clouds: who hasn't gazed at the clouds and imagined faces and animal forms? This wall hanging also includes a compressed view into deep space. At its centre is a red head, representing a man looking into the distance at two *inuksuit* – stone monuments – that are transforming into humans. At the same time the man's thought of another person is visualized by the double face in white. The scene is completed by a human-headed falcon flying down from above to attack the man. All of these story elements are combined into an elegant symmetrical design using dynamic contrasting colours. In this work Avaalaaqiaq shows an extraordinary ability to abstract fully dimensional space and a complicated story into a flat design.

In the wall hanging *Inuksuk Transforming into a Human*, 1999 (plate 23), the arch or *niungvaliruluit* form of the *inuksuk* suddenly increases to gigantic proportions, trapping a woman beneath. The *niungvaliruluit inuksuk* is built to serve as a navigation guide. The correct route is revealed by looking through the opening to the next *inuksuk*.[35] In this wall hanging, the woman escapes the monster Inuksuk by beating on the sides of the huge arch and finally transforming into a bird.

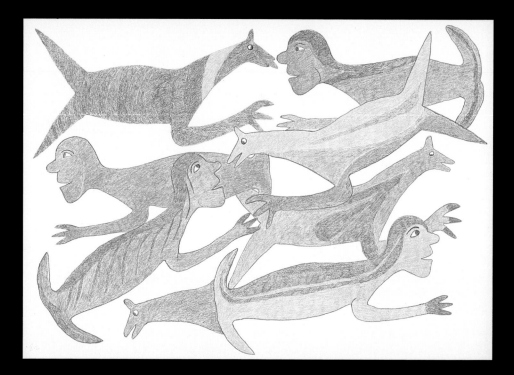

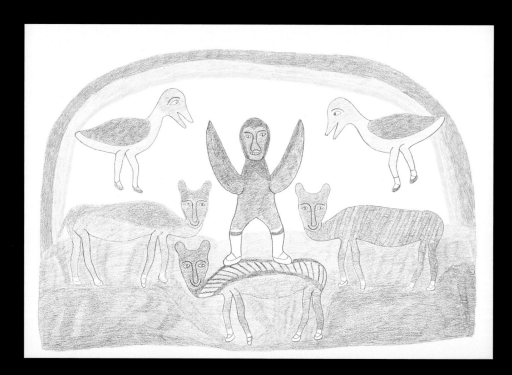

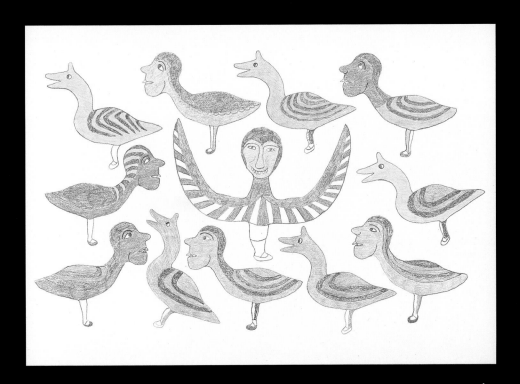

PLATE 20
Flying Away, 1999
coloured pencil
on paper

PLATE 21
Pretty Face, 1999
coloured pencil
on paper

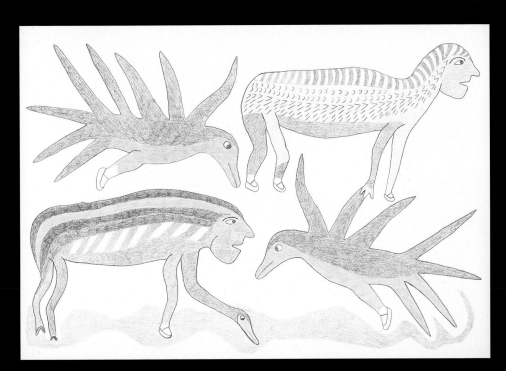

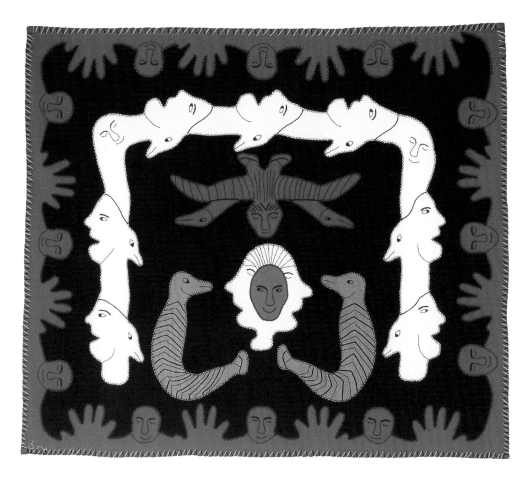

PLATE 22
The Rainbow, 1994
wool duffle and felt, cotton embroidery thread

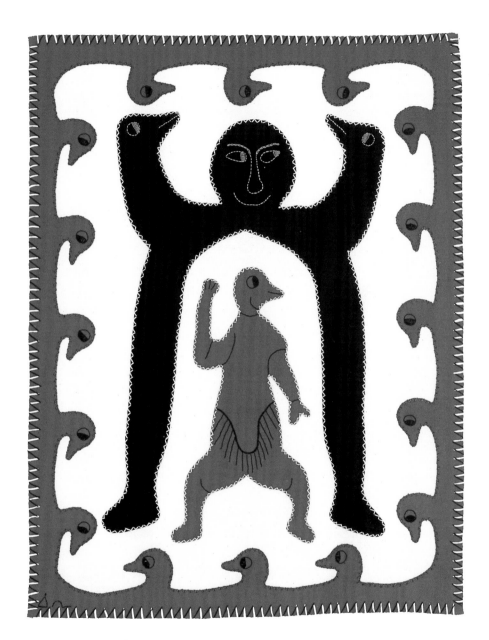

PLATE 23
Inuksuk Transforming into a Human, 1999
wool duffle and felt, cotton embroidery thread

Inuksuit continue to be of practical as well as symbolic importance to Inuit today. Many of them, whether ancient or newly constructed, designate a special place or a favourite camping site. Avaalaaqiaq relies on such navigational aids when she hunts using her snowmobile. These prominent stone monuments often appear in her work in a transforming state, adopting human or magical attributes. They are a link to her childhood experience of walking alone, searching for food or attempting to seek assistance.

The word *inuksuk* means "acting in the capacity of a person." Norman Hallendy points out that, in addition to *inuksuit* that serve as navigational aids or as directional guides for the caribou hunt, other *inuksuit* possess spiritual or magical attributes. He notes, however, that "Their spiritual or religious function was rarely divulged. They are a physical manifestation of spiritual power, and many are objects of veneration. Some served to mark the thresholds of spiritual landscape for the (people) who felt compelled to build them out of love, loneliness or fear."

Hallendy describes different types of *inuksuit*, such as those that may have been created to cast a spell, those that can transform into different entities, and those that are believed to contain a spirit. There is one at which a traveler leaves an offering, another that has stones believed to possess spiritual power, and there are various arch forms. Among these are the *kataujaq*, a place where the shaman heals or protects a person; the *kattaq*, an entrance to a place of power, such as a sacred site; the *tupqujaq*, a doorway through which a shaman enters the spirit world; and the *angaku'habvik*, where shamans receive their powers upon initiation.

Other *inuksuk*-like objects and structures, including the human-shaped *innunguaq*, could have the sinister purpose of focusing a curse or openly displaying the absolute love of a person or place felt by its maker. "There are not that many real *innunguait* to be seen," one elder explained to me. "I have heard that your children make their own *innunguaq* in the wintertime. You call it a snowman. There is a special kind of *innunguaq* – I have forgotten its name – but it too was made of snow. This was a fearsome snowman because it was made by a shaman. It was made to capture the spirit of the person that the shaman wished to harm. Secret words were spoken to it until it possessed

the person's spirit. Then the shaman would take either a knife or a harpoon and kill the snowman. I have been told that the person, even if he was far away, would surely die."[36]

In Avaalaaqiaq's wall hanging *Woman Transforming into a Fish and a Bird*, 2001 (plate 24), three *inuksuit* roll up out of the black border, assuming the form of evil snowmen. The woman considers transforming into a fish to escape, but changes her mind when she realizes she might sink if she enters the water. Instead she changes her head into a bird and flies away.

The calming nature of the animal world is the theme explored in the wall hanging *Multiple Headed Humans*, 1994 (plate 25). In this work the *inuksuit* are not evil forces but elements of goodness as they comfort the young child who is alone out on the land. The child is being "babysat" by a woman whose *amautik* sprouts five bird heads. The animals are companions rather than threats as the child is cared for by the animal spirits.

Being an orphan alone on the land is the subject of a major wall hanging, *Fear of Being Alone*, 1998 (plate 26). The central image in this work is that of an orphaned boy who is transforming into a goose as his arms become goose heads. The rising sun appears as a red head superimposed on his torso, with radiating sunbeams expressed as bands of yellow embroidery. This powerful emblem-like image is created as a symmetrical design in the bold colours of red, blue, and black. Avaalaaqiaq explains:

My grandmother told me a long time ago people used to abandon orphans by leaving them alone on the land. People used to mistreat children when they were orphans. That's the story behind this wall hanging. This boy is all alone in the world and he does not know that anyone else exists. His only companions are the geese since they make noises out in no man's land. He wants to become a goose and to be able to understand them. When the sun rises it becomes bright and it begins to warm up. He finds joy when the sun starts to rise. The sun smiles with the boy and his arms start changing into geese. The boy is also jumping. That is why I have shown him with four legs to represent jumping.

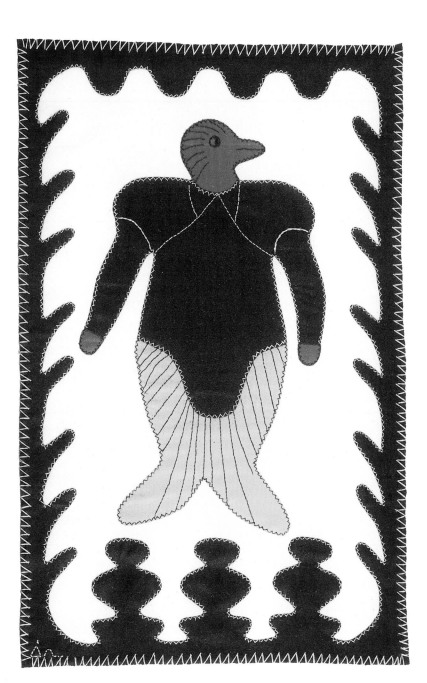

PLATE 24
Woman Transforming into a Fish and a Bird, 2001
wool duffle and felt, cotton embroidery thread

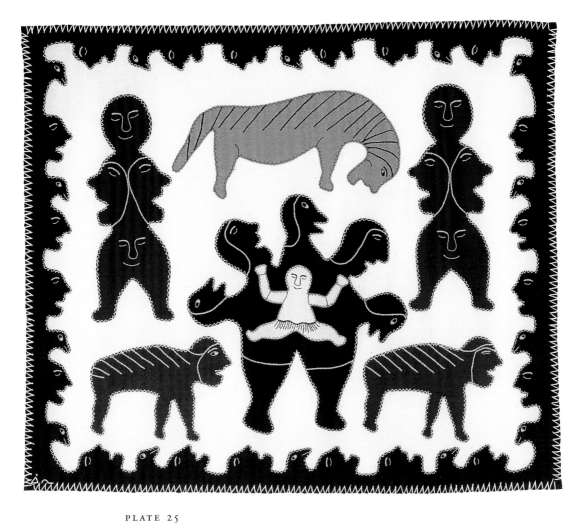

PLATE 25
Multiple Headed Humans, 1994
wool duffle and felt, cotton embroidery thread

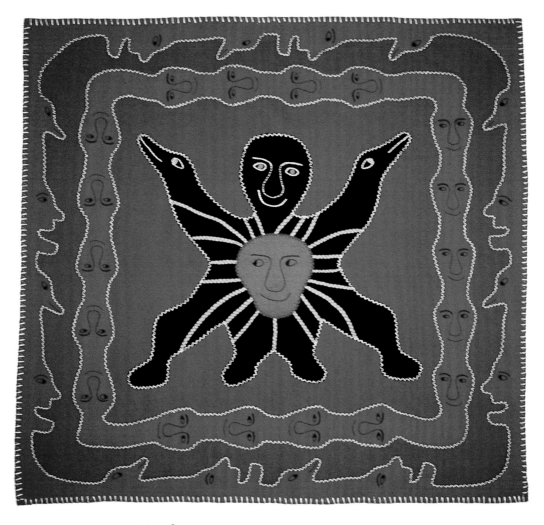

PLATE 26
Fear of Being Alone, 1998
wool duffle and felt, cotton embroidery thread

The scene takes place on a clear day, depicted by the blue background that represents the sky. As the sun starts to rise clouds begin to form into shapes, such as geese and human heads. This is represented by the red outer border. The inner border is people protecting the boy. They are acting like a shield, to prevent the orphan from being attacked by the creatures in the outer border. The orphan takes solace from the positive force of the dawn, and through his magical powers he becomes one with the natural world. Avaalaaqiaq uses the double border format in this work to situate the scene at dawn, and to express the human helping spirits watching over the orphan boy. This compelling image expresses the loneliness and insecurity she felt herself as an orphan.

Rasmussen relates the traditional story of Akataq, the orphan who survives through his own resourcefulness. Neighbours are plotting to kill the boy, but his foster-father trains him to build up his strength by running up the slippery sides of a large *iglu*. His enemies are startled by this formidable opponent and spare his life.[37]

In another story an orphan boy's brother avenges the abuse suffered by his younger brother. He accomplishes the murder of the perpetrators by sending his helping spirit, an ermine, up through the urine hole into the *iglu*. The ermine enters the victim's trouser leg and exits by the cuff of his sleeve.[38]

There is a definite link between Avaalaaqiaq's art and her past. As an orphan she experienced a fractured childhood, during which she was emotionally and physically abused after her grandmother died. In works like *Fear of Being Alone* (plate 26) and *Woman Alone* (plate 12) she achieves a resolution with this aspect of her past as she emphasizes themes of fortitude and escape. Her depictions of being alone on the land mirror a number of her own experiences.

Once when I was a young child I was told to go to another camp to get dried meat. I was always scared of caribou and wolves, but I had a dog with me. When I was near the camp which was my destination, a young male caribou came straight toward me. I went into a small hole in the ground and held onto the dog. I pretended to make a howling sound like a wolf so that the caribou would flee. The caribou fled and I was so happy because I didn't have a rifle.

Avaalaaqiaq's style is highly individualistic. Although she has traveled to Baltimore, Ottawa, Toronto, Guelph, and Vancouver, where she has viewed public art collections, her art shows no evidence of any influence from contemporary mainstream Western art. In a similar fashion she does not "collect" her own work or the work of fellow artists. Art is viewed as a vehicle for personal expression, a means to supplement income and provide for one's family, and as an important source of self-esteem. Her strong focus on oral stories has led to a consistency of style and subject matter throughout her career.

Avaalaaqiaq, similar to other Inuit artists, does not hang her own work in her home. Her house is filled with things that are of value to her – family photographs, a map, certificates and awards received by family members. However, she has a strong commitment to use the vehicle of art to pass on to her grandchildren the stories and culture of her youth that were passed on to her by her grandmother.

Of all the Baker Lake women who make wall hangings she is perhaps the most interested in making a name for herself as an artist and having her work well received by collectors in the south. This has meant learning to function within the mainstream cultural expectation that artists are part of the marketing process. In 1973 she went to Toronto with interpreter Ruth Seeteenak for the opening of her solo exhibition of wall hangings at the Innuit Gallery of Eskimo Art (later renamed The Isaacs/Innuit Gallery).

This was my first time to go south that was not for medical reasons. Ruth and I stayed inside the hotel without going anywhere because we were scared. We were treated so well, Ruth and I were given a soda pop. We sniffed it because we were suspicious that they put alcohol in our drinks. I know now that they wouldn't do that. The person that was looking after us told us not to leave the hotel. We went to the restaurant close by and bought all kinds of food. It was dark too. Probably because of running back and forth and going up and down the elevator I vomited when we were going back up.

When we returned to Winnipeg it felt like home. We stayed at the hotel all day long without going out because we were scared. We could have shopped around by walking instead of spending all day at the hotel room.

How pitiful! In the evening we went out when it became dark and we saw a big movie outside at a drive-in theater. We were so scared we went back inside.

In 1988 I was invited to Ottawa for the grand opening of the National Gallery, where some of my wall hangings were on display. I developed gallstones while I was in Ottawa. Sally Webster was with us. I was in pain and taken to a hospital. I wanted to be discharged from the hospital to go to the opening party and they listened to me. At the opening of the Gallery I went to the washroom as I felt sick. A person from the National Gallery who was looking after us wanted to check on me and to cool me down as she knew I was sick. There was another Inuit lady with us. I think her name was Tasseor from Arviat. The *qablunaat* lady that was looking after us was cooling Tasseor's forehead, with a paper towel. The lady thought it was me. Tasseor was just enjoying being cooled on the forehead. Sally came in and asked the *qablunaaq* lady, "What are you doing?" The lady said, " I'm cooling Irene." Sally said, "She's not Irene." She was cooling the wrong lady. Tasseor, who was being cooled off, was feeling just fine. In spite of feeling sick I was very proud to see my wall hangings hung at the National Gallery.

Avaalaaqiaq skinning a caribou, 2001

Ever since I've been sewing wall hangings. It has been fun. When Marie Bouchard came to Baker Lake and became my art dealer I purchased a washing machine and dryer. I felt I had so much when I purchased my first Ski-Doo. I bought a Ski-Doo twice. The people down South, who purchase art, would understand the wall hangings, drawings, and carvings better if the stories about them were written down so they could understand.[39] We make art just like what the *qablunaat* make in the same sense.

Like most of her fellow Baker Lake artists, she primarily works alone in her own home, with little involvement with the other artists. Her interaction is more on a community level, such as attending the square dances that were originally introduced into Inuit culture by Scots working for the Hudson's Bay Company. Other social activities include wedding celebrations, church services, and family celebrations, such as an elaborate feast of caribou and arctic char to welcome a new grandchild. Her household is an intensely busy place with frequent visitors. Feasting is a symbol of family unity and a celebration of abundance, particularly now that food sources are readily available. For Avaalaaqiaq it is also the culmination of a hunting society's food quest, a quest that controlled her early life when she was living a nomadic existence. Now in the security of a heated home and with a steady income from her art sales, she can fulfill the ultimate family responsibility of helping to provide an abundance of food, other essentials, and gift giving.

In 1922 Rasmussen noted the joy of feasting and song fests among the Harvaqtormiut after a successful caribou hunt. He also commented on their love of gambling: "Peculiarly enough, these people appeared to be passionate gamblers and had apparently been so long before they came into contact with white men. It is without doubt a custom that is connected to singing feasts and song contests which are often wound up by exchanging or gambling away many of their valuable possessions."[40] Gambling as a form of socializing continues today through the popularity of bingo, an activity Avaalaaqiaq participates in with a keen sense of competitiveness.

Her involvement with other artists' work is generally limited to seeing pieces at her Baker Lake art dealer's. Baker Lake Fine Arts Limited was established by Marie Bouchard in 1986. Bouchard promoted the wall hanging artists and reinforced

Avaalaaqiaq with her family, 2001

with them the concept of fabric art as a powerful communication and documentation medium for expressing remembered events and the myths and legends of their culture.[41] Since 1997 it has been owned by Sally Qimmiu'naaq Webster. Both women have helped Avaalaaqiaq reach potential buyers and secure important commissions, such as the wall hanging *Helping Spirits* (plate 27), 1997, which was commissioned by the Department of Foreign Affairs and International Trade for the Canadian consulate in New York.

Avaalaaqiaq discusses the subject of *Helping Spirits*:

> In traditional times, animal and human spirits were considered equal. Animals could transform themselves into humans and humans could transform themselves into animals. Some animal spirits were considered to be helping spirits. If humans were frightened or confused, they could call on an animal's spirit for protection and guidance. By thinking about the animal, the human could assume that creature's strength, or speed, or other abilities.
>
> This wall hanging depicts this ancient belief. The two figures at the top represent the central figure's thoughts. Constantly worried about offending

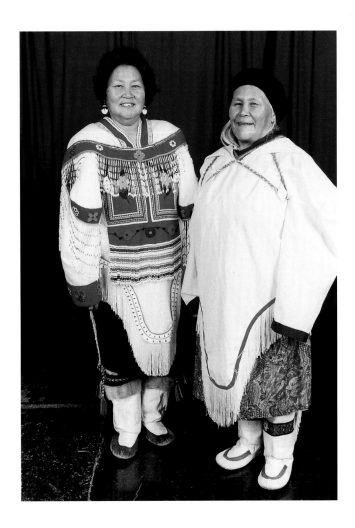

Sally Qimmiu'naaq Webster
and Irene Avaalaaqiaq, 1999

the lingering spirits of deceased animals and humans – depicted on the
outside border – the central figure is saying:

> "If I am afraid, I can turn into a
> wolf and quickly run away. If the
> wolf's speed is not sufficient, I
> can turn into a bird and fly far away."

The gold coloured inner border shows how animals and humans were
interdependent and how the animal spirits protected the humans.[42]

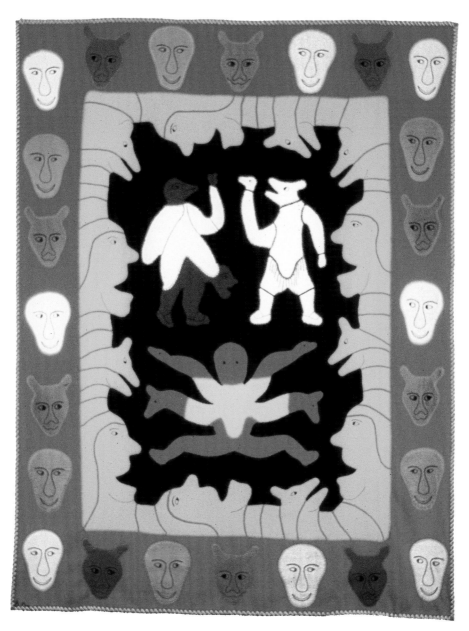

PLATE 27
Helping Spirits, 1997
wool duffle, stroud, and felt, cotton embroidery thread

The dealer provides the material so the artists can work at home, often amidst kitchen and other domestic chaos and family responsibilities such as babysitting. The artists take their completed work directly to the dealer, who then sends it to national and international markets primarily through dealers in the south that specialize in Native Art. This level of support is important since most of the older artists, like Avaalaaqiaq, speak only Inuktitut. Other art dealers and private entrepreneurs in the community are also successfully creating new markets for Baker Lake art, particularly among American collectors.

In 1994, Qatqamiut: The Baker Lake Historical Society presented the Baker Lake Art Symposium, which featured an exhibition of forty-four drawings by nineteen artists that represented the thirty-five-year history of drawing by the Baker Lake artists. The exhibition, titled *Qamanittuaq: Where the River Widens*, was the first survey of Baker Lake drawings and the first touring exhibition organized by a southern gallery to open in an Arctic settlement. This exhibition was organized by the Macdonald Stewart Art Centre at the University of Guelph and the drawings were selected from the Art Centre's Inuit art collection, which has a specialization in contemporary Inuit drawings.[43] The exhibition was held in the community hall adjacent to Avaalaaqiaq's home, at the heart of the settlement. For the twelve living artists represented in the exhibition it was a remarkable

Avaalaaqiaq discussing her drawing *Imagination Visions* at the Baker Lake Art Symposium, 1994

experience. Some of the artists had never seen their own work hung in an exhibition before. For others it was an opportunity to become aware of their fellow artists' work and to learn about and celebrate the important history of drawing in their community.

The twelve artists – Irene Avaalaaqiaq, Marjorie Esa, Hannah Kigusiuq, Janet Kigusiuq, Myra Kukiiyaut, Victoria Mamnguqsualuk, William Noah, Nancy Pukingrnak, Ruth Qaulluaryuk, Simon Tookoome, Ruth Annaqtussi Tulurialik, and Marion Tuu'luq – participated in the opening events. Highlights included the exhibition opening ceremony, when a sinew rope was cut with an *ulu* (traditional woman's knife). This was followed by drum dancing, throat singing, a demonstration of dog whip skills by Simon Tookoome, and a caribou feast. Country and western songs were sung in Inuktitut by Ruth Annaqtussi Tulurialik, accompanied by her husband, Hugh, on the guitar. Most of the settlement's 1,500 inhabitants attended along with the symposium participants, who had come from across Canada and the United States. Outside the community hall, three oil barrels bubbled with steaming broth containing a selection of caribou heads and haunches. The party-goers brought their own bowls and utensils, and following the feast square dancing began and continued until close to dawn.

The symposium included a showing of traditional clothing and an exhibition of forty recent wall hangings held in the high school gymnasium. The first Canada Council for the Arts Art Bank jury to be held in the Arctic was conducted during the symposium. The result was the purchase of a significant number of wall hangings, drawings, and sculptures for this Ottawa collection, which rents art to government and corporate offices.

The following day the artists spoke at the symposium, discussing their individual drawings in the exhibition and their experiences as artists. During the artists' and curators' seminar artist William Noah said that many Inuit works had been sold in the past without recording the artist's description of the subject and that this must change. He commented, "It is often the piece the artist likes the least that the southern buyer selects, being attracted to a roughly finished sculpture. The piece the artist carefully finished and attached a story to is turned down. This can be discouraging to an artist."

Baker Lake, view from
the Jessie Oonark Art and
Crafts Centre, 1994

Artist Hannah Kigusiuq further commented that it was critical that northern
dealers and cooperatives stay active since most artists, especially the older ones, do
not speak English and are unfamiliar with southern business practices.[44]

In June 1998 The Right Honourable Roméo LeBlanc, CC, CMM, CD, opened
the new Itsarnittakarvik: Inuit Heritage Centre, which was established at the
request of the elders to preserve and promote the unique inland culture of the dif-
ferent groups of Inuit who now reside in Baker Lake. Since the opening of this
Centre other exhibitions have been held, and under the direction of manager
David Webster and assistant manager Lucy Evo there has been a number of show-
ings of Baker Lake art, including a major show of sculpture curated by Marie
Bouchard in 2000. This exhibition is being circulated by the Heritage Centre in
association with the Art Gallery of Ontario. Avaalaaqiaq's husband, David Tik-
taalaaq, was a prominent carver and is represented in this exhibition by a work
titled *Musk Ox/Bird Transformation*. Avaalaaqiaq represented her husband by par-
ticipating in the opening ceremonies for this exhibition. Opportunities to see
fellow Inuit artists' work and touring exhibitions at the Heritage Centre are
increasing communications among the artists and enhancing the vibrancy of the
Baker Lake art community.

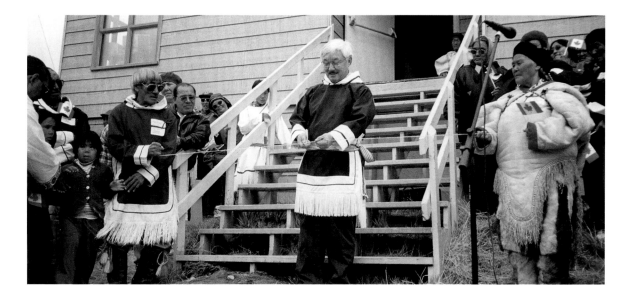

With the wall hanging *Bird Figures*, 1998 (plate 28), Avaalaaqiaq is exploring a perhaps more contemporary theme. Selecting a wife is the subject of this work, in which a woman who is transforming into a goose is confronted by two men who are performing shamanic rituals. The border consists of rows of heads. She explains:

> This is a story from a long time ago when severed heads of animals and humans were hung inside the *iglu*. In the middle of the scene is a very beautiful woman who is wearing a pink *amautik*. The men on either side are admiring her but she doesn't want anything to do with them.
>
> The men said "We will turn into geese and wolves unless you marry us." One of the severed heads hanging in the *iglu* said, "Look what these mean men did to us." The woman transforms herself into a goose and is pecking the men with her sharp beak. The men quickly decide to leave her alone.

Avaalaaqiaq gives a feminist spin to the traditional story of prospective husbands competing to win the hand of a bride. In the past the matter was often settled by the men having fist-fights or engaging in duels of strength that were

Avaalaaqiaq (representing her late husband) at the opening of "An Inuit Perspective: Baker Lake Sculpture," 1 July 2000, with Peter Irniq, commissioner of Nunavut, and Thomas Qaqimat, carver.

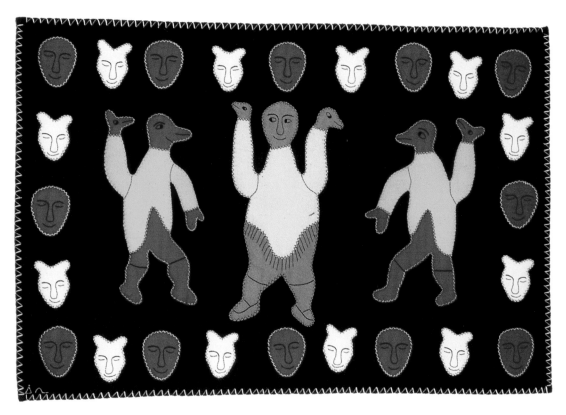

PLATE 28
Bird Figures, 1998
wool duffle and felt, cotton embroidery thread

overseen by the elders. In her wall hanging a grotesquerie of severed heads warns the bride-to-be to take matters into her own hands, which she does very effectively. The artist is also commenting on arranged marriages, like her own, which were common in the past. She adds, "Today it is more often that young men and women choose their own marriage partners."

In commenting on her life today she reflects on her past:

When I was a child I never thought about being poor or having a hard time because we never saw anything big or new.

Right now I seem to be living in a harder way than when I was younger. There is too much to worry about so I seem to get sick more often now. Back then I was very happy even though there were just three of us, my grandparents and me. Although we didn't have a Bible we knew there was a white man up in heaven who was looking after us. When I was growing up we never went hungry because my grandparents would always find food.

It makes me feel a lot better physically and mentally when I talk about the hardships I went through, although they sound bad. I am very thankful to God for looking after me when I was younger. I love all the children who are mistreated and have lost both parents. I know how hard it is when someone mistreats you. Even hearing parents scold their kids in a loud voice hurts me. Although they mistreated me I thank them for raising me to be as old as I am now and know they are still hurting for mistreating me.

Siksigaq asked me to name my first daughter after him, so she would help me when she was older, because he couldn't help me when I was being mistreated. So I named my first daughter after him. A long time ago men weren't allowed to argue with their wives even though they weren't doing the right thing. That is why Siksigaq was unable to help me when I was being mistreated. He also told me that whoever was bad to me would have a hard time.

Avaalaaqiaq's wall hangings and drawings are an expression of her identity and a summation of her life expressed on a symbolic plane. By combining her own experiences with her commitment to honour her grandmother, she has created an extensive body of work focused on spirit imagery and transformation. Through

her art Avaalaaqiaq also affirms her emotional attachment to her homeland. She feels deeply about the loss of her traditional nomadic culture resulting from having to adapt to a settlement lifestyle with its Western ways. By recording her grandmother's oral stories, she extends the mythological world of the collective consciousness of those Inuit who once lived in the manner of their ancestors on the Barren Grounds. Her themes of being alone, of loneliness, of escape, and of the transformative powers of nature appear throughout her work, presenting a magical world where myth and reality intersect.

Her deep desire to make her work accessible to a broad audience was realized when she began to be included in exhibitions in southern Canada and internationally and her work was included in major public collections. These moments of recognition brought their own poignancy as she again had to adapt to new challenges, in this case to the rigours of the Western world's business of being a successful artist. On learning that she would be receiving an honorary degree from the University of Guelph she commented: "I never thought that my work would ever be recognized in this way."

With extraordinary breadth of insight, Avaalaaqiaq expresses the real and unseeable realms in symbolic visual form. Oral traditions of storytelling and the passing on of moral tales find a new mode of telling in these highly dramatic and powerfully expressive wall hangings and drawings. Her urgency to create these ever evolving themes is to our benefit, as we are exposed to yet another intriguing aspect of human nature.

Appendix 1
Information about Plates

Note: Quotes by Irene Avaalaaqiaq about individual art works not already
incorporated into the text are included with the catalogue entries.
All works bear Avaalaaqiaq's Inuktitut signature in syllabics.

PLATE 1
Young Man Out Walking, 1989
wool duffle and felt, cotton embroidery thread
75 cm x 97.8 cm
Purchased with funds raised by the Art Centre Volunteers, 1989
Macdonald Stewart Art Centre Collection
MS989.004
Note: Titled by Avaalaaqiaq in 2001.
Exhibitions:
Baltimore, The Baltimore Museum of Art, *Northern Lights, Inuit Textile Art from
 the Canadian Arctic*, 17 November 1993 – 30 January 1994, no. 5. Listed as
 Untitled.

Guelph, Macdonald Stewart Art Centre, 11 June – 18 July 1994.

Winnipeg, Winnipeg Art Gallery, 17 August – 9 October 1994.

Guelph, Macdonald Stewart Art Centre, *Selections from the Inuit Art Collection*, 15 February – 1 October 1995.

Waterloo, Ontario, University of Waterloo Art Gallery, *Spirit Imagery*, 16 January – 7 March 1997.

"The red figure in the centre is an Inuk who has triumphed over the animals and the forces that are surrounding him. The lines running through his body represent his veins and the little orange stitches in the veins indicate that the veins are swelling with blood as he raises his arms in celebration. A line of black stitches surrounds the Inuk like a barrier protecting him from harm." From Fernstrom and Jones, 41 (1993)

"The black border is the hills rising high when it became nighttime. The red figure is a young man out walking. He became scared and was surrounded by leaves which protected him. The brown figure at the top was also protecting the boy. The birds around him were transforming themselves into human heads and were trying to attack him. The heads at the sides were laughing at him saying, 'Are you afraid of us because we have human faces just like you?' While laughing at the boy, they grew more eyes on their faces. The two yellow figures were humans but their heads came off and landed on their bums. The boy wanted to fly but he couldn't so he was protected by the leaves. The two brown figures at the bottom are old bones. They were once a wolf and a human but became bones and worms." (2001)

PLATE 2

Men Who Want to Be Animals, 1999

coloured pencil on paper

70 cm x 101.5 cm

Commissioned with funds raised by the Art Centre Volunteers, 1999

Macdonald Stewart Art Centre Collection

MS993.070
Exhibitions:
Guelph, Macdonald Stewart Art Centre, *Where Myth, Dream and Reality Inter-sect: The Art of Irene Avaalaaqiaq*, 23 September 1999 – 20 February 2000.

"These two men are sometimes unhappy to be human. They wish they could become animals. One could turn into a fish whenever he wanted and the other could turn into a bird."

PLATE 3

Woman Fleeing Evil Spirits, 1993
wool duffle and felt, cotton embroidery thread
139 cm x 99 cm
Purchased with funds raised by the Art Centre Volunteers, 1993
Macdonald Stewart Art Centre Collection
MS993.070
Exhibitions:
Guelph, Macdonald Stewart Art Centre, *Inuit Art from the Keewatin District*, 8 June 1995 – 6 October 1996.
Waterloo, Ontario, University of Waterloo Art Gallery, *Spirit Imagery*, 16 January – 7 March 1997.
Guelph, Macdonald Stewart Art Centre, *Where Myth, Dream and Reality Inter-sect: The Art of Irene Avaalaaqiaq*, 23 September 1999 – 20 February 2000.

PLATE 4

The Shaman Calls His Friends, 1980
stencil print
52.6 cm x 75.3 cm
Purchased with funds raised by the Art Centre Volunteers, 2001
Macdonald Stewart Art Centre Collection
MS2001.002

No. 11, 1980 Baker Lake Print Collection catalogue, printed by H. Amitnaaq.
Exhibitions:
Winnipeg, The Upstairs Gallery, *Irene Avaalaaqiaq, Baker Lake Wall Hangings and Vintage Prints*, 9–23 September 2000.

"The friends (birds) are ganging up on the figure in the centre. They are wolves that became shamans."

PLATE 5
Happy Spring Has Returned, 1981
wool felt, cotton embroidery thread
69.5 cm x 98 cm
Purchased with funds raised by the Art Centre Volunteers, 2001
Macdonald Stewart Art Centre Collection
MS2001.003
Exhibitions:
Winnipeg, The Upstairs Gallery, *Irene Avaalaaqiaq, Baker Lake Wall Hangings and Vintage Prints*, 9–23 September 2000.

PLATE 6
Mysterious Powers of the Shaman, 1974
wool duffle and felt, cotton embroidery thread
82 cm x 61.8 cm
Collection of the Canadian Museum of Civilization
IV-C-4721
Exhibitions:
Hull, Canadian Museum of Civilization, *In the Shadow of the Sun*, 9 December 1988 – 31 August 1990.
Hull, Canadian Museum of Civilization, *Tradition and Regeneration*, 17 December 1992 – 2 May 1993.

Northern Lights: Inuit Textile Art from the Canadian Arctic: Baltimore, The Baltimore Museum of Art, 17 November 1993 – 30 January 1994
 Guelph, Macdonald Stewart Art Centre, 11 June – 18 July 1994.
 Winnipeg, Winnipeg Art Gallery, 17 August – 9 October 1994.
Toronto, The Museum for Textiles, *A Stitch in Time*, Toronto, 3 May – 2 November 1997.

"The red frame is the sunrise. The yellow is the snow. I had only white felt then so I used yellow. The black represents nighttime. The figure in the centre of the wall hanging looks like a caribou or a wolf. This caribou said, 'It is too scary, I want to become a human.' So it started to have human legs. The man on the left side said, 'Don't change yourself into a human because you'll become a slow runner like me.' When the caribou was still trying to transform himself into a human, the man took an *ulu* (knife) and cut off the caribou's human head. The ptarmigan who was behind the man transformed itself into a human and said to the man, 'Don't do that, never do that, that's what happened to all of us. We all became nothing but heads.' The woman on the right side is trying to fly because she is afraid of all the heads, but she was never able to develop wings. Being scared, the woman took her *ulu*, but the *ulu* handle became a human head so she just dropped it and tried to fly. The woman has pockets on her socks."

PLATE 7
Untitled, 1975
wool duffle and felt, cotton embroidery thread
310 cm x 150 cm
Commissioned by the Province of Manitoba for the Federal Department of Public Works for Canada for the Town Centre Complex, Churchill, Manitoba; Centre opened April 1976.

The composition is arranged in three bands:
"The white band at the bottom is the snow; the red band in the middle is the

sunrise; and the blue band at the top represents a nice clear day when it is getting dark. My grandmother used to tell me that humans and animals used to transform themselves. So the figures are all transforming animals and humans. The figure in the centre of the bottom band is the shaman. When the shaman was casting spells his legs and arms started to change. They were nothing but flesh without any bones. The figures around the shaman became scared so they turned away. In the centre of the middle band there are two black figures which are big rock boulders which started to look like humans or birds. The figure in the centre of the top band is an *inuksuk*. A long time ago at nighttime the *inuksuit* used to move like people by developing human legs. Two red figures beside the *inuksuk* transformed themselves from birds into humans. They asked the *inuksuk*, 'Why do you look like a human now?' The inuksuk replied, 'I wanted to see what you would do when I transformed myself into human.' They told the *inuksuk*, 'We can also transform ourselves into humans and fly.' When they were no longer afraid of the *inuksuk* they walked away."

PLATE 8
Willow Bushes, 1970s
graphite and coloured pencil on paper
38.5 cm x 55.5 cm
Purchased with funds donated by Blount Canada Limited, 1993
Macdonald Stewart Art Centre Collection
MS993.047
Exhibitions:
Qamanittuaq: Where the River Widens, Drawings by Baker Lake Artists,
Macdonald Stewart Art Centre touring exhibition, no. 65.
 Baker Lake, Baker Lake Community Hall, 18–24 August 1994.
 Guelph, Macdonald Stewart Art Centre, 27 April – 10 September 1995.
 St. John's, Memorial University Art Gallery, 12 January – 3 March 1996.
 Winnipeg, Winnipeg Art Gallery, 14 September – 17 November 1996.
 London, McIntosh Gallery, University of Western Ontario, 9 January –
 9 February 1997.
 Ottawa, Carlton University Art Gallery, 18 February – 13 April 1997.

Traverse City, Michigan, Dennos Museum Centre, 1 June – 1 September 1997.

Montgomery, Alabama, Montgomery Museum of Fine Art, 28 March –
 24 June 1998.

Kelowna, Kelowna Art Gallery, 3 June – 29 August 1999.

Phoenix, Arizona, Heard Museum, 15 April 2000 – 15 January 2001.

PLATE 9

All Different Thoughts, 1978

stencil print

55.8 cm x 76.2 cm

Gift of Dr and Mrs E. Daniel Albrecht, 2000

Collection of the Heard Museum, Phoenix, Arizona

No. 21, 1978 Baker Lake Print Collection catalogue, printed by Martha Noah.

Exhibitions:

Phoenix, Arizona, Heard Museum, *Canadian Inuit Art from the Collection of
 Dr and Mrs E. Daniel Albrecht*, 15 April 2000 – 15 January 2001.

PLATE 10

Imagination Visions, 1980s

coloured pencil on paper

56 cm x 42 cm

Purchased with funds donated by Blount Canada Limited, 1993

Macdonald Stewart Art Centre Collection

MS993.048

Exhibitions:

Qamanittuaq: Where the River Widens, Drawings by Baker Lake Artists,
 Macdonald Stewart Art Centre Touring exhibition, no. 66.

PLATE 11

Husband and Wife, 1999

wool duffle and felt, cotton embroidery thread

153.5 cm x 172.75 cm
Commissioned with funds raised by the Art Centre Volunteers, 1999
Macdonald Stewart Art Centre Collection
MS999.066
Exhibitions:
Guelph, Macdonald Stewart Art Centre, *Where Myth, Dream and Reality Intersect: The Art of Irene Avaalaaqiaq*, 23 September 1999 – 20 February 2000.

"The husband and wife were having fun playing around. The man turned away from his wife to perform shamanism and his head became a ptarmigan. As soon as the woman saw her husband doing magic she right away thought she should be strong so she became a wolf and a big fish. The woman is shouting to the *tolugaq* (the ravens) to help them, 'You are so black so become human and help us.' As the ravens are flying down to land they are becoming humans. The border is the sky becoming dusk and the rocks are becoming people."

PLATE 12
Woman Alone, 1999
wool duffle and felt, cotton embroidery thread
152.5 cm x 186.75 cm
Macdonald Stewart Art Centre Commission
Donated in memory of John and Lillian Goatley by David and Judith Nasby and their children, Graham and Sarah, 1999
Macdonald Stewart Art Centre Collection
MS999.067
Exhibitions:
Guelph, Macdonald Stewart Art Centre, *Where Myth, Dream and Reality Intersect: The Art of Irene Avaalaaqiaq*, 23 September 1999 – 20 February 2000.

"A woman went out to get some firewood and moss. The woman is not happy because she did not get any firewood. She thought she was with two women but they are changing into wolves. The woman is trying to fly away. Wolves are

shamans so their spirits are flying around. The big fish are becoming humans and they are trying to scratch the women. The border is birds and wolves."

PLATE 13
Shaman Hunting Caribou, 1999
coloured pencil on paper
70 cm x 101.5 cm
Commissioned with funds raised by the Art Centre Volunteers, 1999
Macdonald Stewart Art Centre Collection
MS999.062

"The shaman turned into a bird so he could fly and catch the caribou."

PLATE 14
Spirit Figures, 1993
wool duffle and felt, cotton embroidery thread
139.7 cm x 99 cm
Gift of Dr and Mrs E. Daniel Albrecht, 2000
Collection of the Heard Museum, Phoenix, Arizona
Exhibitions:
Phoenix, Arizona, Heard Museum, *Canadian Inuit Art from the Collection of Dr and Mrs E. Daniel Albrecht*, 15 April 2000 – 15 January 2001.

PLATE 15
Human Becomes Wolf, 1999
wool duffle and felt, cotton embroidery thread
151 cm x 147 cm
Commissioned with funds raised by the Art Centre Volunteers, 1999
Macdonald Stewart Art Centre Collection
MS999.057

Exhibitions:

Guelph, Macdonald Stewart Art Centre, *Where Myth, Dream and Reality Intersect: The Art of Irene Avaalaaqiaq*, 23 September 1999 – 20 February 2000.

"It is late summer. There is no snow and the sun is setting. The border has birds and people who are starting to make a noise. They are saying, 'How come there are yellow heads?' The central figure replies, 'I can transform into anything. The yellow heads are the people I ate when I transformed into a wolf.' One of the yellow heads says, 'This person is really one of us,' and the other yellow heads started to laugh. The central figure then becomes scared and transforms into a bird to escape."

PLATE 16

Inukpak: Giant Person Who Eats Hands, 1992
wool duffle and felt, cotton embroidery thread
180 cm x 120 cm
Private Collection

PLATE 17

Giant Transforming, 2000
wool duffle and felt, cotton embroidery thread
152.5 cm x 56 cm
Purchased with funds raised by the Art Centre Volunteers with the financial assistance of the Canada Council for the Arts, 2001
Macdonald Stewart Art Centre Collection
MS2001.004

"A giant woman was walking around at sunrise when the red heads in the border started making fun of her. She told them, 'Don't make fun of me, I have power to do anything.' The faces on her legs started shouting at the red heads.

When her arms and legs turned into birds, these birds told the giant she could only escape by flying."

PLATE 18
Fighting Creatures, 1999
coloured pencil on paper
70 cm x 101.5 cm
Commissioned with funds raised by the Art Centre Volunteers, 1999
Macdonald Stewart Art Centre Collection
MS999.060
Exhibitions:
Guelph, Macdonald Stewart Art Centre, *Where Myth, Dream and Reality Intersect: The Art of Irene Avaalaaqiaq*, 23 September 1999 – 20 February 2000.

"Seven creatures started to transform. Four changed into half human and half fish and three changed into half wolf and half fish. They started to fight and the creatures that turned into half wolves won the fight."

PLATE 19
Helping Birds, 1999
coloured pencil on paper
70 cm x 101.5 cm
Commissioned with funds raised by the Art Centre Volunteers, 1999
Macdonald Stewart Art Centre Collection
MS999.063
Exhibitions:
Guelph, Macdonald Stewart Art Centre, *Where Myth, Dream and Reality Intersect: The Art of Irene Avaalaaqiaq*, 23 September 1999 – 20 February 2000.

"It was starting to get dark but the rainbow was still showing. There were three wolves who had human faces and feet. The woman said, 'I'm not afraid of the

wolves.' She stepped on the back of the wolf and said, 'I am going to fly away.' The birds told the woman, 'We are not scared, we will help you fly.'

PLATE 20
Flying Away, 1999
coloured pencil on paper
70 cm x 101.5 cm
Commissioned with funds raised by the Art Centre Volunteers, 1999
Macdonald Stewart Art Centre Collection
MS999.061
Exhibitions:
Guelph, Macdonald Stewart Art Centre, *Where Myth, Dream and Reality Inter-sect: The Art of Irene Avaalaaqiaq*, 23 September 1999 – 20 February 2000.

"Five of the figures in the circle are ptarmigans and they are laughing. The other six figures are ptarmigans with human heads but they have teeth like wolves. The human shaman in the middle is trying to catch the creatures but isn't having any luck. He says, 'I can't catch you, so I am going to fly away.'

PLATE 21
Pretty Face, 1999
coloured pencil on paper
70 cm x 101.5 cm
Commissioned with funds raised by the Art Centre Volunteers, 1999
Macdonald Stewart Art Centre Collection
MS999.065
Exhibitions:
Guelph, Macdonald Stewart Art Centre, *Where Myth, Dream and Reality Inter-sect: The Art of Irene Avaalaaqiaq*, 23 September 1999 – 20 February 2000.

"The animals started to change. The musk ox (lower left) grew a human foot and a bird leg. The two birds each grew a human foot and started to look

strange and scary. The musk ox (top right) did not change much and he is still pretty."

PLATE 22
The Rainbow, 1994
wool duffle and felt, cotton embroidery thread
122 cm x 142 cm
Collection of Verne and Heather Harrison
Exhibitions:
Baker Lake, Jonah Amittnaaq High School, *Recent Wall hangings*, 18–23 August 1994.
Guelph, Macdonald Stewart Art Centre, *Where Myth, Dream and Reality Intersect: The Art of Irene Avaalaaqiaq*, 23 September 1999 – 20 February 2000.

"The red border represents clouds turning into people. The people are trying to see the rainbow, which is the white, inset border. The central red face represents a man looking into the distance at the *inuksuit*, which seem half human and half stone. The double face behind the man represents his thoughts. The red bird above is a falcon which is going to grab the man."

PLATE 23
Inuksuk Transforming into a Human, 1999
wool duffle and felt, cotton embroidery thread
96.5 cm x 74.4 cm
Private Collection
Exhibitions:
Guelph, Macdonald Stewart Art Centre, *Where Myth, Dream and Reality Intersect: The Art of Irene Avaalaaqiaq*, 23 September 1999 – 20 February 2000.

"The white is snow, as if we were in Baker Lake. The border is when it is becoming dusk and the geese are flying up at sunset. The black image is an *inuksuk*. When it became dark the *inuksuk* transformed into a human with arms

like a bird. A woman was trying to get some water. When she went under the arch she became frightened. She said, 'I will transform into a bird so I can fly away.' She is trying to hit the *inuksuk* person as she is flying away."

PLATE 24
Woman Transforming into a Fish and a Bird, 2001
wool duffle and felt, cotton embroidery thread
75.5 cm x 119.5 cm
Purchased with funds raised by the Art Centre Volunteers with the financial
 assistance of the Canada Council for the Arts, 2002
Macdonald Stewart Art Centre Collection
MS2002.001

"This woman was out walking when the *inuksuit* and the twigs started to change and surround her. She thought she would be saved if she changed into a big fish and jumped into the water. But she thought she might sink if she were a fish. She said, 'I think it would be better if I get a head like a bird instead.' When she said that her head turned into a bird and she flew away."

PLATE 25
Multiple Headed Humans, 1994
wool duffle and felt, cotton embroidery thread
125 cm x 144 cm
Collection of Bruce and Lesley Campbell
Exhibitions:
Baker Lake, Jonah Amittnaaq High School, *Recent Wall hangings*, 18–23 August
 1994.
Guelph, Macdonald Stewart Art Centre, *Where Myth, Dream and Reality Inter-
 sect: The Art of Irene Avaalaaqiaq*, 23 September 1999 – 20 February 2000.

"The five headed central figure is babysitting the child who is so scared it wants to fly away. Two *inuksuit* (top left and right) are turning into humans and they

are trying to comfort the child. Two musk oxen with human heads (bottom left and right) are also trying to comfort the child. The brown musk ox (top centre) is talking to the child, 'Don't be scared, I will help to look after you.'"

PLATE 26

Fear of Being Alone, 1998

wool duffle and felt, cotton embroidery thread

137.2 cm x 147.3 cm

Gift of Dr and Mrs E. Daniel Albrecht, 2000

Collection of the Heard Museum, Phoenix, Arizona

Exhibitions:

Vancouver, Marion Scott Gallery, *Two Great Image Makers from Baker Lake: Irene Avaalaaqiaq and Josiah Nuilaalik*, 27 February – 20 March 1999.

Phoenix, Arizona, Heard Museum, *Canadian Inuit Art from the Collection of Dr and Mrs E. Daniel Albrecht*, 15 April 2000 – 15 January 2001.

PLATE 27

Helping Spirits, 1997

wool duffle, stroud, and felt, cotton embroidery thread

289.75 cm x 228.75 cm

Commissioned by the Department of Foreign Affairs and International Trade for the Canadian consulate, New York

PLATE 28

Bird Figures, 1998

wool duffle and felt, cotton embroidery thread

99 cm x 148.6 cm

Gift of Dr and Mrs E. Daniel Albrecht, 2000

Collection of the Heard Museum, Phoenix, Arizona

Exhibitions:

Phoenix, Arizona, Heard Museum, *Canadian Inuit Art from the Collection of Dr and Mrs E. Daniel Albrecht*, 15 April 2000 – 15 January 2001.

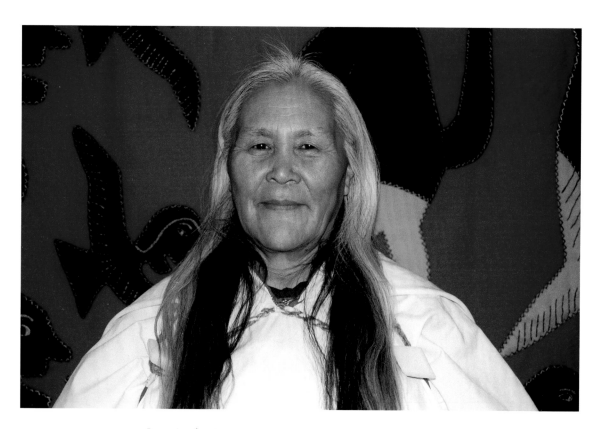

Irene Avaalaaqiaq, 1999

Appendix 2
Exhibitions and Honours

Irene Avaalaaqiaq (TIKTAALAAQ; TAALAAQ; AHVALAKIAK; AVALAKIAK; AHVALAQUAQ) was born in 1941 on the north shore of Tebesjuak Lake (Kazan River area). She moved to Baker Lake, in what is now Nunavut, in 1958. Avaalaaqiaq began drawing and making wall hangings around 1970. Although her major medium is wall hangings, she also makes sculpture and since 1973 has had prints included in most of the annual Baker Lake Print Collections.

She is represented by Baker Lake Fine Arts Limted in Baker Lake, Nunavut; The Upstairs Gallery, Winnipeg; and the Marion Scott Gallery, Vancouver.

SOLO EXHIBITIONS

1973 *Wall Hangings: Embroidered and Appliquéd: by Ahvalakiak of Baker Lake.* The Innuit Gallery of Eskimo Art, Toronto, Ontario.

1993 *Wall Hangings by Irene Avaalaaqiaq.* The Isaacs/Innuit Gallery, Toronto, Ontario.

1999 *Where Myth and Reality Intersect: The Art of Irene Avaalaaqiaq.* Macdonald Stewart Art Centre, Guelph, Ontario.

2000 *Irene Avaalaaqiaq, Baker Lake Wall Hangings and Vintage Prints.* The Upstairs Gallery. Winnipeg, Manitoba.

SELECT GROUP EXHIBITIONS

1973 *Stones and Bones of Baffin Island.* The Arctic Circle. Los Angeles, California.

1974 *Eskimo Wall Hangings.* McIntosh Gallery. University of Western Ontario, London, Ontario. (brochure)

1974 *Crafts from Arctic Canada/Artisanat de l'arctique canadien.* Canadian Eskimo Arts Council. Ottawa, Ontario. (illustrated catalogue) (tour)

1974 *Baker Lake Sculpture.* The Innuit Gallery of Eskimo Art. Toronto, Ontario. (illustrated catalogue)

1975, 1976 *Baker Lake Print Collection.* (artist) (annual collection) (illustrated catalogue)

1978, 1979

1980, 1981

1982, 1984

1985, 1986

1988, 1990

1975, 1979 *Baker Lake Print Collection.* (printer) (annual collection) (illustrated catalogue)

1981, 1982

1984, 1985

1986, 1987

1977–1982 *The Inuit Print/L'estampe inuit.* National Museum of Man and Department of Indian Affairs and Northern Development. Ottawa, Ontario. (illustrated catalogue) (tour)

1978 *Baker Lake Wall Hangings 1978.* The Innuit Gallery of Eskimo Art. Toronto, Ontario.

1979 *Spirits and Dreams – Arts of the Inuit of Baker Lake.* Department of Indian Affairs and Northern Development. Ottawa, Ontario. (illustrated brochure) (tour)

1979 *Baker Lake Wall Hangings 1979*. The Arctic Circle. Los Angeles, California.

1980 *Baker Lake Prints – Ten Year Retrospective*. The Upstairs Gallery. Winnipeg, Manitoba.

1983 *Hunter of the Sacred Game: Traditional Life on the Land*. Organized by the Arts and Learning Services Foundation. Minneapolis, Minnesota. (tour)

1983 *Baker Lake Prints and Print-Drawings: 1970–1976*. Winnipeg Art Gallery. Winnipeg, Manitoba. (illustrated catalogue)

1983–1985 *Grasp Tight the Old Ways: Selections from the Klamer Family Collection of Inuit Art*. Art Gallery of Ontario. Toronto, Ontario. (illustrated catalogue) (tour)

1987–1988 *Inuk, Inuit: Art et tradition chez les esquimaux d'hier et d'aujour-d'hui* presented by L'Iglou Art Esquimau, Douai, at Musée des Beaux-arts d'Arras. Arras, France. (illustrated catalogue)

1987–1989 *Contemporary Inuit Drawings*. Macdonald Stewart Art Centre. Guelph, Ontario. (illustrated catalogue) (tour)

1988 *L'art inuit*. Presented by l'Iglou Art Esquimau, Douai at Palais de L'Europe. Le Touquet, France.

1988–1989 *In the Shadow of the Sun (Im Schatten der Sonne: Zeitgenossische Kunst der Indianer und Eskimos in Kanada)*. Canadian Museum of Civilization. Hull, Quebec. (illustrated catalogue) (tour)

1989 *Collecting Inuit Art – Shifting Perceptions*. Agnes Etherington Art Centre. Queen's University, Kingston, Ontario. (illustrated catalogue)

1989 *Art Inuit, la Sculpture des Esquimaux du Canada*. Presented by l'Iglou Art Esquimau, Douai at Chapelle de la Visitation. Thonon, France.

1989 *Baker Lake Prints: 1970–1982 Retrospective*. Inuit Gallery of Vancouver. Vancouver, British Columbia. (illustrated catalogue)

1989 *Baker Lake Print Retrospective: A Twenty Year Anniversary*. The Upstairs Gallery. Winnipeg, Manitoba. (illustrated catalogue)

1990 *Art Inuit, la Sculpture des Esquimaux du Canada*. Presented by

l'Iglou Art Esquimau, Douai at Centre d'Action Culturelle du Bassin Houllier, Lorrain. Saint Avold, France.

1990 *In the Shadow of the Sun*. Canadian Museum of Civilization. Hull, Quebec. (illustrated catalogue)

1990 *Baker Lake Wall Hangings*. The Isaacs/Innuit Gallery. Toronto, Ontario.

1991 *The Great Northern Art Festival*. Held in Inuvik, Northwest Territories.

1991 *Sojourns to Nunavut: Contemporary Inuit Art from Canada*. At Bunkamura Art Gallery, presented by the University of British Columbia Museum of Anthropology and the McMichael Canadian Art Collection. Tokyo, Japan. (illustrated catalogue) (tour)

1992 *Women of the North: An Exhibition of Art by Inuit Women of the Canadian Arctic*. Marion Scott Gallery. Vancouver, British Columbia. (illustrated catalogue)

1993 *Multiple Realities: Inuit Images of Shamanic Transformation*. Winnipeg Art Gallery. Winnipeg, Manitoba. (illustrated brochure)

1993 *Tradition and Regeneration*. Canadian Museum of Civilization. Hull, Quebec.

1993–1994 *Northern Lights: Inuit Textile Art from the Canadian Arctic*. The Baltimore Museum of Art, Baltimore, Maryland. (illustrated catalogue) (tour)

1994 *Recent Wall Hangings*. Jonah Amittnaaq High School. Baker Lake, Nunavut.

1994 *Patiently I Sing*. Selections from the Tyler/Brooks Collection, Carleton University Art Gallery. Ottawa, Ontario. (illustrated catalogue)

1994 *Kunst aus der Arktis*. Volkerkundmuseum der Universität Zurich. Zurich, Switzerland. (illustrated catalogue)

1994–2003 *Qamanittuaq: Where the River Widens, Drawings by Baker Lake Artists*. Macdonald Stewart Art Centre, Guelph, Ontario. (illustrated catalogue) (tour)

1995 *Keeping Our Stories Alive: An Exhibition of the Art and Crafts from Dene and Inuit of Canada*. Institute of American Indian Arts Museum. Santa Fe, New Mexico. (illustrated catalogue)

1995 *Selections from the Inuit Art Collection.* Macdonald Stewart Art Centre. Guelph, Ontario.

1996 *Arctic Mystery, Harmony and Transformation, Baker Lake Textile Art.* Organized by Arctic Inuit Art. Art Gallery of the Canadian Embassy, Washington, D.C.

1996 *Inuit Art from the Keewatin District.* Macdonald Stewart Art Centre. Guelph, Ontario.

1997 *Inuit II: New Acquisitions to the Herman Collection of Inuit Drawings.* Muscarelle Museum of Art. College of William and Mary, Williamsburg, Virginia. (illustrated catalogue) (tour)

1997 *Spirit Imagery: Inuit Art from the Macdonald Stewart Art Centre Collection.* University of Waterloo Art Gallery, Waterloo, Ontario.

1997 *A Stitch in Time: The History and Aesthetics of Baker Lake Wall Hangings.* The Museum for Textiles. Toronto, Ontario.

1998–2001 *Qamanittuaq Drawings from the Collection of Macdonald Stewart Art Centre,* Macdonald Stewart Art Centre, Guelph, Ontario. (illustrated catalogue) (tour)

1999 *Two Great Image Makers from Baker Lake: Irene Avaalaaqiaq and Josiah Nuilaalik.* Marion Scott Gallery. Vancouver, British Columbia. (illustrated catalogue)

2000 *Canadian Inuit Art: Selections from the Collection of Dr and Mrs E. Daniel Albrecht.* Heard Museum. Phoenix, Arizona.

2000 *The Storyteller's Hand: Inuit Drawings from the Frederick and Lucy S. Herman Collection.* University Gallery. University of Delaware, Newark, Delaware.

2001 *Inuit Art 1950–2000.* Macdonald Stewart Art Centre. Guelph, Ontario.

2002 *Recent Baker Lake Wall Hangings.* Marion Scott Gallery. Vancouver, British Columbia.

2002 *Asingit, Inuit Art from Macdonald Stewart Art Centre.* Kunstgeschichte der Leopold-Franzens-Universität Innsbruck. Innsbruck, Austria. (illustrated catalogue) (tour)

COLLECTIONS

Agnes Etherington Art Centre, Queen's University, Kingston, Ontario

Amway Environmental Foundation Collection, Ada, Michigan

Art Gallery of Ontario, Toronto, Ontario

Canadian Guild of Crafts Quebec, Montreal, Quebec

Canadian Museum of Civilization, Hull, Quebec

Carleton University Art Gallery, Ottawa, Ontario

CIBC Collection, Toronto, Ontario

Confederation Centre Art Gallery and Museum, Charlottetown,
 Prince Edward Island

Dennos Museum Center, Northwestern Michigan College, Traverse City,
 Michigan

Heard Museum, Phoenix, Arizona

Indian and Northern Affairs, Canada, Ottawa, Ontario

Itsarnittakarvik: Inuit Heritage Centre, Baker Lake, Nunavut

Kitchener-Waterloo Art Gallery, Kitchener, Ontario

Macdonald Stewart Art Centre, Guelph, Ontario

McMaster Museum of Art, McMaster University, Hamilton, Ontario

McMichael Canadian Art Collection, Kleinburg, Ontario

Mendel Art Gallery, Saskatoon, Saskatchewan

Musée des beaux-arts de Montréal, Montréal, Québec

Museum of Anthropology, University of British Columbia, Vancouver,
 British Columbia

National Gallery of Canada, Ottawa, Ontario

Prince of Wales Northern Heritage Centre, Yellowknife, Northwest Territories

University of Alberta, Edmonton, Alberta

University of Delaware, Newark, Delaware

University of Lethbridge Art Gallery, Lethbridge, Alberta

University of New Brunswick, Fredericton, New Brunswick

Winnipeg Art Gallery, Winnipeg, Manitoba

HONOURS, ACHIEVEMENTS, AND COMMISSIONS

1973 Received a Canada Council travel grant to attend the opening
 of her first solo exhibition at The Innuit Gallery of Eskimo Art
 in Toronto.

c. 1974 Wall hanging commission for the foyer of L'Esplanade Laurier Centre, Ottawa. Centre opened in 1975.

1975 Wall hanging commissioned by the Province of Manitoba and the Federal Department of Public Works of Canada for the Town Centre Complex, Churchill, Manitoba. Complex opened April 1976.

1976 Commissioned by Public Works Canada to create two wall hangings for post offices in Ilderton and Wyoming, Ontario.

1979 A wall hanging by Avaalaaqiaq was presented to the State of Minnesota by the Canadian Ambassador to the U.S.A. and now hangs in the State Legislature in Minneapolis.

1980 Travelled to Winnipeg to attend the official opening of the 1980 Baker Lake Print Collection.

1988 Attended the gala opening of the new National Gallery of Canada in Ottawa.

1993 Tied for third prize in the wall hanging competition at the Keewatin Arts and Crafts Festival.

1993 Attended the opening of the *Northern Lights* exhibition in Baltimore, where she spoke about her life and work as well as demonstrating embroidery and appliqué techniques.

1997 *Helping Spirits*, 1997 wall hanging commissioned by the Department of Foreign Affairs and International Development for the Canadian consulate, New York.

1999 The University of Guelph, Guelph, Ontario confers the degree Doctor of Laws, *honoris causa*, upon Irene Avaalaaqiaq. Macdonald Stewart Art Centre commissions three wall hangings and six drawings to celebrate Avaalaaqiaq receiving this honorary degree.

2002 Member, Royal Canadian Academy

Note: Biographical information based on files at the Inuit Art Centre, Indian and Northern Affairs Canada, with additional information compiled by the author.

Appendix 3
Honorary Degree Citation and Address

HONORARY DEGREE CITATION

Mr Chancellor

On the recommendation of the Senate of the University of Guelph, I have the honour to present the candidate.

IRENE AVAALAAQIAQ

for the degree of Doctor of Laws, *honoris causa.*

 Irene Avaalaaqiaq is an outstanding and prolific artist whose commitment to her family oral traditions has resulted in a unique series of pictures created with fabric and embroidery floss. Her characteristic subjects of transforming human, vegetable, and animal life forms are witness to the continuing presence of the traditional spiritualism of legends and myths which inform her highly original visual interpretations.

Born in 1941 in the Kazan River area of Nunavut, Irene Avaalaaqiaq spent the first thirteen years of her life in relative isolation. She was raised by her grandparents after her mother died early in her childhood. She learned how to sew caribou clothing and these sewing skills found their way into the wall hangings she created after moving to Baker Lake in 1958. Much of her subject matter originates from the legends of her grandmother. She has mastered several art media: drawing, printmaking, wall hangings and sculpture. Her works have been featured in several national and international exhibitions.

Avaalaaqiaq's work is included in numerous public and private collections, including the National Gallery of Canada, Winnipeg Art Gallery, Macdonald Stewart Art Centre, and the University of Delaware.

Irene Avaalaaqiaq is deeply involved in her community of Baker Lake as a senior artist and a mentor to younger artists. Her dynamic, highly coloured works communicate about Inuit traditions that are rapidly becoming part of the past. Her fervent wish is that this knowledge of her culture will be passed on to future generations.

Mr Chancellor: It is with great pleasure that I call upon you now to honour this great artist and the University by conferring the degree of Doctor of Laws, *honoris causa,* upon Irene Avaalaaqiaq.

presented by
Carole Stewart
Dean of Arts
19 October 1999

ADDRESS BY IRENE AVAALAAQIAQ
AT THE UNIVERSITY OF GUELPH CONVOCATION

Mr Chancellor, Mr President, distinguished guests, families, friends, and graduating students:

My name is Irene Avaalaaqiaq and I am from Baker Lake, Nunavut. Baker Lake is the only inland Inuit community in Canada and is also the geographic centre of Canada. As we do not have marine life, we depend on caribou for food and clothing.

It is a great honour to be recognized by the University of Guelph. It makes me feel proud that my art is recognized after so many years of being an artist. When Sally told me, I just ran around the living room, as I could not sit still.

Now I am here and it is happening.

I grew up at a time when Inuit did not live in communities. I was brought up on the land. It was a hard life as we lived in an *iglu* in the winter and a caribou skin tent in the summer. My education was from my grandparents. Inuit did not write their history down like people do in the South, but we passed on our traditions, culture and values through an oral tradition. Through the oral tradition our ancestors were our teachers.

I try to keep our culture alive through my art. Each wall hanging I do tells a story or a legend. Art is a way to preserve our culture.

In the winter we would sit in our *iglu* and listen to the stories and legends our elders would tell us. Most of the stories and legends had a moral to them and we would use the values taught to us in our everyday life.

We did not have schools to go to learn but we did get an education. It was very different from yours. If Inuit did not learn well, they would not survive in the harsh climate. We had to learn in order to live. The father taught the boys how to hunt and the mother would teach the girls to sew. Now times have changed and a lot of women hunt, but the men have still not learned to sew too well.

You are lucky. You have a beautiful university and the chance to learn many things. How you learn and how I learned are so completely different, so opposite. I never even attended school and you have been at school most of your life.

Times have changed so much. At least my education was free and I did not have to get a student loan …

Education is necessary and essential, but getting a good education is only part of having a good life. You have to have a dream and ambition. Sometimes a dream might seem impossible and some people give up, as it seems it can never be achieved. Don't ever lose that dream, don't be negative about it but always be positive and pursue that dream. You might have a few falls but keep pursuing that dream and never give up. It will happen if you believe and really want it to happen. Inuit had a dream about having more control over their destiny and now we have Nunavut. You can do anything you want if you set your mind to it.

You are so fortunate and I sincerely wish you every success in life. If you ever want to come to Baker Lake let Sally or me know and we will make you feel welcome. I don't know you personally but I care for you and hope you have a successful life where your ambitions have been achieved. You worked hard to finish university and have had the guidance of your parents and professors. Now you are old enough to be on your own and your life is in your hands, you will make your own decisions. Don't ever forget your parents who love you and have helped you for so many years. Tell them today that you love them. Respect your elders as they have a lot of wisdom.

Canada is the greatest country in the world and is made up of people from many cultures. Be proud of your heritage, as I am proud to be an Inuk and a Canadian. Don't forget the traditions of your ancestors, as they are your roots. Don't forget who you are and where you came from. Try to understand people with different backgrounds and learn about their culture. It will make your life richer and fuller.

I thank you all so much as you have given me a great honour. This was one of my dreams and it has happened.

I invite you all to see my work at an exhibition that Judy Nasby has organized. That way I can meet you as an individual and not as a group.

Thank you all so much and God bless you.

Notes

1 Rasmussen, *Intellectual Culture*, 7. Rasmussen describes the *Harvaqtormiut* as living in various settlements around the lower Kazan River (5). His associate, Birket-Smith, noted that these camps moved often and that the western boundary for the *Harvaqtormiut* was less definite because groups tended to move northwest toward important fishing places between Baker Lake and Schultz Lake (64). Avaalaaqiaq's birthplace is approximately 250 kilometres west of the lower Kazan River. Irene's husband, David Tiktaalaaq, was born in 1927 at Itimnik at the end of Trinity Mile Lake on the Kazan River.

2 Ibid., 9.

3 Ibid., 25.

4 Birket-Smith, *The Caribou Eskimos*, 53.

5 Martin, *In the Spirit of the Earth*, 48–9.

6 Rasmussen, *Intellectual Culture*, 27.

7 Ibid., 56.

8 Carpenter, *Padlei Diary*, n.p.

9 Oberman and Tookoome, *The Shaman's Nephew*, 48–9. Independent art consultant Marie Bouchard states that her research

indicates 19 people died at Garry Lake, three or four at Chantrey Inlet, and a small number at Padlei during the winter of 1957–58.

10 Jackson, Nasby, and Noah, *Qamanittuaq*, 17.

11 Keith, "Baker Lake," 232–5.

12 Von Finckenstein, *Celebrating Inuit Art*, 23.

13 Jackson, Nasby, and Noah, *Qamanittuaq*, 35.

14 Whitton, "The Baker Lake Eskimo," 1; quoted Fernstrom and Jones, *Northern Lights*, 11.

15 Jackson, Nasby, and Noah, *Qamanittuaq*, 36.

16 Butler, "Wall Hangings from Baker Lake," 29.

17 Jackson, Nasby, and Noah, *Qamanittuaq*, 36.

18 Settler, Faye. Introduction to *Baker Lake 1978 Prints/Estampes*.

19 Fernstrom and Jones, *Northern Lights*, 40.

20 Birket-Smith, *The Caribou Eskimos*, 222.

21 Ibid., 255.

22 Rasmussen, *Intellectual Culture*, 25–6.

23 Avaalaaqiaq, interview with Anne McPherson.

24 Rasmussen, *Intellectual Culture*, 90. Rasmussen noted that the stories he collected were common to all Caribou Inuit.

25 Ibid., 48.

26 Fernstrom and Jones, *Northern Lights*, 18.

27 Avaalaaqiaq, interview with Marie Bouchard, 1992.

28 Ibid.

29 Rasmussen, *Intellectual Culture*, 108.

30 Ibid., 114.

31 Wight, *Multiple Realities*, 1.

32 Oonark, interview, 38.

33 Wight, *Inuit Woman*, 4.

34 Rasmussen, *Intellectual Culture*, 89.

35 Hallendy, *Inuksuit*, 117.

36 Ibid., 77.

37 Rasmussen, *Intellectual Culture*, 106.

38 Ibid., 18.

39 "South" refers to anyone living south of Nunavut or the Northwest Territories.

40 Rasmussen, *Intellectual Culture*, 14.

41 Fernstrom and Jones, *Northern Lights*, 30.

42 Avaalaaqiaq, interview with Marie Bouchard, 1997.

43 Among world institutions collecting Canadian Inuit art, the Macdonald Stewart Art Centre at

the University of Guelph is unique in its focus on building a specialized collection of contemporary drawings. The Art Centre is involved with researching, exhibiting, and publishing scholarship on this collection and promoting it to a wide audience. Generous sponsorship from the Guelph company Blount Canada Limited, which donated purchase funds, enabled the Art Centre to begin the collection in 1980. Since then, the Art Centre has acquired over 400 drawings by Canadian Inuit artists. These works date from the early 1960s to the present, and are complemented by the other major Inuit art media: sculpture, wall hangings, and printmaking. The collection also contains 50 wall hangings primarily by Baker Lake artists. The Art Centre is fortunate to have invaluable commentary by the artists about many of the works in the collection. Additional art purchase funds for Inuit art have been provided by the Canada Council for the Arts, the Ontario Government through the Ministry of Citizenship, Culture, and Recreation, and by the Art Centre Volunteers. The Art Centre has also received gifts of art from numerous individuals and groups in Canada and abroad. Touring exhibitions of Inuit art from this collection have been shown in Canada, the United States, Iceland, India, and Austria.

44 Jackson, Nasby, and Noah, *Qamanittuaq*, 12.

Baker Lake, 1994

Bibliography

Avaalaaqiaq, Irene. Interview with Marie Bouchard, Baker Lake, 1992.

– Interview with Anne McPherson, Baker Lake, 1994.

– Interview with Marie Bouchard, Baker Lake, 1997.

Baker Lake Print Collection Catalogues. 1975, 1976, 1978, 1979, 1980, 1981, 1982, 1984, 1985, 1986, 1988, 1990.

Birket-Smith, Kaj. *The Caribou Eskimos: Material and Social Life and Their Cultural Position.* Report of the Fifth Thule Expedition 1921–24, vol. 5. Copenhagen: Gyldendal, 1929.

Blodgett, Jean. *The Coming and Going of the Shaman: Eskimo Shamanism and Art.* Winnipeg: Winnipeg Art Gallery, 1978.

– *Grasp Tight the Old Ways.* Toronto: Art Gallery of Ontario, 1983.

– "Christianity and Inuit Art." 1988. Reprinted from *The Beaver*, Autumn 1994. In Houston, Alma, ed., *Inuit Art: An Anthology.* Winnipeg: Watson and Dwyer, 1998.

Bouchard, Marie. "Making Art in Baker Lake." *Inuit Art Quarterly* (Summer 1989): 6–9.

– *"Irene Avaalaaqiaq."* In *North American Women Artists of the*

Twentieth Century: A Biographical Dictionary/Garland, 1995.

– *An Inuit Perspective, Baker Lake Sculpture from the Collection of the Art Gallery of Ontario, Gift of Samuel and Esther Sarick.* Baker Lake: Itsarnittakarvik: Inuit Heritage Centre, 2000.

Brown, Deborah and Mary Jo Hughes Genosko. *Collecting Inuit Art – Shifting Perceptions.* Kingston: Agnes Etherington Art Centre, 1989.

Butler, Sheila. "Wall Hangings from Baker Lake." *The Beaver* 303:2 (Autumn 1972): 26–31.

– "The First Printmaking Year at Baker Lake: Personal Recollections." *The Beaver* 306:4 (Spring 1976): 17–26.

– "Baker Lake Revisited." *C Magazine, Contemporary Art Quarterly* 45 (Spring 1995): 24–33.

Butler, Sheila and Bernadette Driscoll. *Baker Lake Prints and Print Drawings, 1970–76.* Winnipeg: Winnipeg Art Gallery, 1983.

Canadian Arctic Producers. "Exhibition of Wall Hangings by Ahvalakiak of Baker Lake." *CAP Newsletter* (Spring 1973): 3.

– "Keewatin Wall Hangings." Ottawa: Canadian Arctic Producers, 1979.

Carpenter, Edmund, ed. *Padlei Diary, 1950. An account of the Paleimiut Eskimo in the Keewatin District west of Hudson Bay during the Early Months of 1950 as Witnessed, Written and Photographed by Richard Harrington.* Rock Foundation, 2000.

Colakovic, Marina R. "Mytho-Poetic Structure in the Inuit Tale of Kivioq the Wanderer (Inuit Story-telling in the Light of Oral Literature Theory)." Occasional paper. Guelph: Macdonald Stewart Art Centre, 1993.

Dickie, Bonnie. "Marie Bouchard and the Baker Lake Renaissance: Creating a New Partnership Between Dealer and Artists." *Up Here* (October 1994): 28–32.

Driscoll, Bernadette. *Inuit Myths, Legends & Songs.* Winnipeg: Winnipeg Art Gallery, 1982.

Driscoll-Engelstad, Bernadette. "A Woman's Vision, A Woman's Voice: Inuit Textile Art from Arctic Canada." *Inuit Art Quarterly* 9:2 (1994): 4–13.

Fernstrom, Katharine W. and Anita E. Jones. *Northern Lights: Inuit Textile Art from the Canadian Arctic.* Baltimore: The Baltimore Museum of Art, 1993.

Fry, Jacqueline. *Baker Lake Prints and*

Drawings. Winnipeg: Winnipeg Art Gallery, 1973.

Gierstad, Ole and Martin Kreelak, directors. *Journey to Nunavut: Amarok's Song.* Video. National Film Board of Canada, 1999.

Greer, Darrell. "Reaching National Prominence: Baker Lake Artist Receives Honorary Degree." *Kivalliq News* 5:10 (1999): 1, 4.

Hallendy, Norman. *Inuksuit, Silent Messengers of the Arctic.* Vancouver: Douglas and McIntyre, 2000.

Institute of American Indian Arts Museum. *Keeping Our Stories Alive: An Exhibition of Art and Crafts from Dene and Inuit of Canada.* Santa Fe, New Mexico: 1995.

Jackson, Marion E., ed. *Patiently I Sing: Selections from the Tyler/Brooks Collection of Inuit Art. (Selected by Mary Haydon, S. Holyck Hunchuck, Christine Lalonde and Helen Rapp).* Ottawa: Carleton University Art Gallery, 1994.

Jackson, Marion Elizabeth. "Baker Lake Inuit Drawings: A Study in the Evolution of Artistic Self-Consciousness." Ph.D. Diss., University of Michigan, 1985.

Jackson, Marion E. and Judith M. Nasby. *Contemporary Inuit Drawings.* Guelph: Macdonald Stewart Art Centre, 1987.

Jackson, Marion E., Judith Nasby, and William Noah. *Qamanittuaq: Where the River Widens: Drawings by Baker Lake Artists.* Guelph: Macdonald Stewart Art Centre, 1995.

Jackson, Marion E. and William Noah. "Artists' Interpretations and Syllabic Translations for the Baker Lake Drawings in the Collection of the Macdonald Stewart Art Centre." Manuscript. Guelph: Macdonald Stewart Art Centre, 1983.

Jordon, Betty Ann. "Irene Avaalaaqiaq." *Canadian Art* (Fall 1994): 108–11.

Kardosh, Bob. *Two Great Image Makers from Baker Lake: Irene Avaalaaqiaq and Josiah Nuilaalik.* Vancouver: Marion Scott Gallery, 1999.

Keith, Darren. "Baker Lake." In *Nunavut Handbook.* Iqaluit: Nortext Multimedia, 1999.

Mannik, Hattie, ed. *Inuit Nunamiut: Inland Inuit.* Baker Lake, 1995.

Marion Scott Gallery. *Women of the North: An Exhibition of Art by Inuit Women of the Canadian Arctic.* Vancouver: Marion Scott Gallery, 1992.

Martin, Calvin Luther. *In the Spirit of the Earth, Rethinking History and Time.* Baltimore: John Hopkins

University Press, 1992.

McGhee, Robert. *The Tuniit: First Explorers of the High Arctic.* Ottawa: National Museum of Canada, 1981.

McPherson, Anne. "Women of Strong Fibre." *Ontario Craft* 20 (1995): 11–16.

Muehlen, Maria. "Baker Lake Wall-Hangings: Starting from Scraps." *Inuit Art Quarterly* (Spring 1989): 6–11.

– "Some Recent Work by Women of Baker Lake." *Inuit Art Quarterly* (Summer/Fall 1992): 30–5.

– "Inuit Textile Arts." In *In the Shadow of the Sun: Perspectives on Contemporary Native Art.* Edited by the Canadian Museum of Civilization. Hull: Canadian Museum of Civilization, 1993.

Nasby, Judith. *Contemporary Inuit Drawings: The Gift Collection of Frederick and Lucy S. Herman.* Williamsburg, Virginia: Muscarelle Museum of Art. College of William and Mary, 1993.

– "Revealing the Truth of the Artist's Hand: Contemporary Inuit Drawing." *Inuit Art Quarterly* (Fall 1994): 4–13.

– *Qamanittuaq Drawings by Baker Lake Artists from the Collection of Macdonald Stewart Art Centre.*

Guelph: Macdonald Stewart Art Centre, 1998.

– "Canadian Art from Baker Lake. Selections from the Collection of Dr and Mrs E. Daniel Albrecht." *Inuit Art Quarterly* (Winter 2000): 43–5.

– *Canadian Inuit Art: Selections from the Collection of Dr and Mrs E. Daniel Albrecht.* Exhibition brochure. Phoenix: Heard Museum, 2000.

– *Asingit: Inuit: Art from Macdonald Stewart Art Centre.* Innsbruck, Austria: Kunstgeschichte der Leopold-Franzens-Universität Innsbruck, 2002.

– "Inuit Art: 1950–2000, an exhibition at Macdonald Stewart Art Centre." *Inuit Art Quarterly* (Summer 2002): 50–2.

National Museum of Man. *The Inuit Print/l'estampe Inuit: A Travelling Exhibition … Une expositions itinerante …* Ottawa: National Museum of Man, National Museums of Canada, 1977.

Oberman, Sheldon and Simon Tookoome. *The Shaman's Nephew, A Life in the Far North.* Toronto: Stoddard Kids, 1999.

Oonark, Jessie, and her children. Interviews by Marion E. Jackson,

Baker Lake, Spring 1983. Interpreted by William Noah and Ruby Arngna'naaq. Unpublished, unedited field data. Inuit Art Section, Indian and Northern Affairs.

Rasmussen, Knud. *Intellectual Culture of the Caribou Eskimos.* Report of the Fifth Thule Expedition 1921–24, vol. 7, nos. 2 & 3. Copenhagen: Gyldendal, 1930.

Settler, Faye. Introduction to *Baker Lake 1978 Prints/Estampes.* Baker Lake: Sanavik Cooperative, 1978.

Swinton, George. *Sculpture of the Inuit.* Toronto: McClelland & Stewart, 1992.

Von Finckenstein, Maria, ed. *Celebrating Inuit Art 1948–1970.* Toronto: Key Porter, 1999.

Webster, Deborah Kigjugalik, compiled by. *Harvaqtuurmiut Heritage.* Baker Lake: Itsarnittakarvik: Inuit Heritage Centre, 2001.

Webster, Sally Qimmiu'naaq. *Tuhaalruuqtut.* Vol. 1. Compact disc. Baker Lake: Spiritwalker, 1998.

Whitton, Elizabeth. "The Baker Lake Eskimo and their Needlecraft." Manuscript, c. 1972. Inuit Art Section, Indian and Northern Affairs.

Wight, Darlene Coward. *Multiple Realities: Inuit Images of Shamanic Transformation.* Winnipeg: Winnipeg Art Gallery, 1993.

– *Inuit Woman: Life and Legend in Art.* Exhibition brochure. Winnipeg: Winnipeg Art Gallery, 1995.

Photograph Credits

Len Anthony, ii, 37

Paul von Baich, Courtesy Inuit Art Centre, Indian and Northern Affairs Canada, 34

Kaj Birket-Smith, Courtesy National Museum of Denmark, 9

Marie Bouchard, 75

Canadian Museum of Civilization (image number S93-643), 38

Christian Coloumbe, Courtesy Itsarnittakarvik: Inuit Heritage Centre, 46

Department of Zoology, University of Guelph, 15

Steven Fick, xi

Peter Green, 29

Elmer Harp, 22-3, 27

Verne Harrison, 78

Hudson's Bay Company Archives, Winnipeg, 6, 7

Lennart Larsen, Courtesy National Museum of Denmark, 41

T.H. Manning, Courtesy Hudson's Bay Company Archives, 17

Zach McLeod, Courtesy Marie Bouchard Consulting, 81

Judith Nasby, 80, 100, 116

Dean Palmer, 2, 11, 36, 48, 50, 52, 55, 59, 62-5, 68-9, 77

Information Services Branch, Province of Manitoba, 39

Knud Rasmussen, Courtesy National Museum of Denmark, 13, 18

John Reeves, 125

Index

About the Author

Judith Nasby has been a curator and public art gallery director for more than twenty-five years. As curator at the University of Guelph in Ontario, she directed the University Art Gallery until 1975 when she began working on the development of the Macdonald Stewart Art Centre. As director, she has been responsible for developing one of the most comprehensive sculpture parks in Canada and overseeing the development of a 4,000-piece permanent collection with a specialization in contemporary Inuit drawings. She has curated over 100 exhibitions and written 50 publications, including a 300-page catalogue of the University of Guelph collection. Inuit art exhibitions that she has curated have toured Canada, the United States, Iceland, Denmark, India, and Austria. She is an adjunct professor in the School of Fine Art and Music at the University of Guelph and in 2001 was named Woman of Distinction in Arts and Culture, YMCA-YWCA.